5.95

William Frith

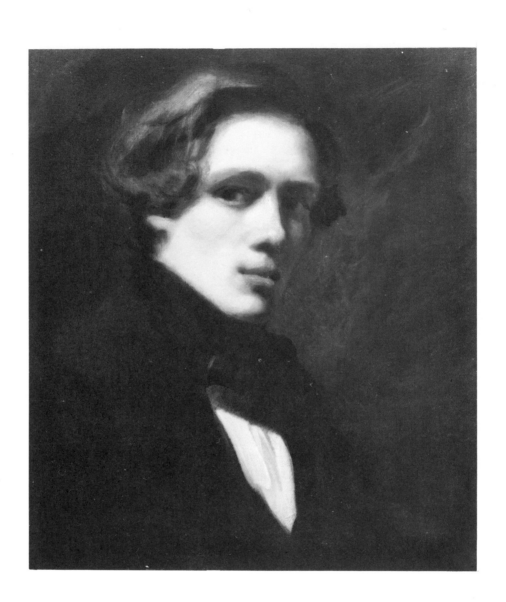

William Frith

Extraordinary
Victorian Painter

A Biographical
& Critical
Essay by
Aubrey Noakes

Jupiter : London

1978

First published in 1978 by
JUPITER BOOKS (LONDON) LIMITED
167 Hermitage Road, London N4 1LZ.

Copyright © Jupiter Books (London) Limited.

ISBN 906379 00 8

Composed in 12pt Monotype Garamond, Series 156,
by Ronset Limited, Darwen, Lancashire; additional
settings by Topic Typesetting Limited, London.
Printed and bound in Great Britain by the
Penshurst Press Limited, Tunbridge Wells, Kent.

I ups and paints, hears no complaints,
 And sells before I'm dry,
Till savage Ruskin sticks his tusk in,
 And all is up with I.

SHIRLEY BROOKS, editor of *Punch*.

Contents

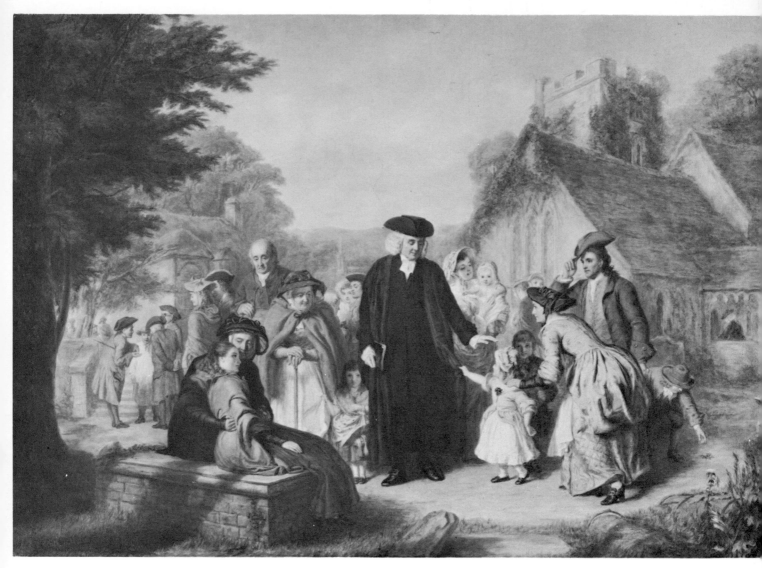

The Village Pastor.

1845. 21¾ x 31½ ins. Courtesy of Christies, London.

Designed to illustrate the following lines from Goldsmith:

The sevice past, around the pious man,
With steady zeal, each honest rustic ran;
E'en children followed with endearing wile,
And plucked his gown to share the good man's smile.

Introduction

MY OWN PERSONAL INTEREST IN FRITH was much stimulated twenty years ago by long conversations about him in the Cheshire Cheese in Fleet Street with the late Neville Wallis, art critic of *The Observer*, when he was working on his abridgement of Frith's *Autobiography and Reminiscences*, published by Geoffrey Bles under the title, *A Victorian Canvas* (1957), which I had the pleasure to review for *The Tablet* (19 October 1957).

As I said at the time, one of the secret joys of the bibliomaniac and inveterate browser in secondhand bookshops is the discovery of wonderfully readable and entertaining works, which our candid friends insist look scruffy and suspect are pitifully dull. But, how little they know! What happens, though, when we are robbed of our secret? When that despised, scruffy volume is reissued in an adroitly abridged version, with all the sly beguilements of modern publishing, complete with a stylish dustjacket, selected plates, footnotes, and a scholarly introduction?

Childlike, our first reaction is to feel a trifle hurt that our secret is no longer a secret. Then, remembering our age, and the good manners beaten into us by determined elders many years ago, we smile and say how pleased we are that all can now share our delight. *Omnis homo mendax*! Such were my reactions when I handled Neville Wallis's volume.

However, I have on my shelves still that battered single-volume edition (the eighth) of the *Autobiography and Reminiscences*, published in 1890. A faintly erased pencil-mark within informs me that it set me back a shilling at some time. During the intervening years I have come to know its contents almost by heart; but how many people suspect just what riches it contains? Too diffuse and rambling, no doubt, for our present, hurrying taste, it remains, nevertheless, a priceless source of information on the Victorian art scene, and our immense debt to it will be clear on every page of the book now in your hands.

Moreover, Frith, with his two wives and nineteen children (as Jeremy Maas

[13]

neatly puts it: Frith liked crowds!), produced at least two writers in his family. His son, Walter, became a novelist and published an entertaining interview-article about Frith when he was in his late eighties ('A Talk With My Father') in the *Cornhill Magazine*, May 1906; and his daughter, 'Cissy' – Jane Ellen Panton (1848–1928) – wrote *Leaves From a Life* (1908) and *More Leaves From a Life* (1911), which usefully augment and round out our picture of life in the household of a fashionable Victorian painter in a most attractive way. She acted as a model as a child and young woman both to her father and his artist-friends, like Augustus Egg, and went on to pose for George du Maurier. She assures us that the faces of her sisters and herself are to be found in volume after volume of *Punch*.

The trouble with Frith was, bluntly, that he lived too long; he outlived his popularity. Six times protective rails had to be erected at the Royal Academy to keep admirers of his pictures at bay; then, having outlived all those who had shared with him, from his student days with Henry Sass, the rewards and sweets of fame 'when the going was good' (like Millais), his popularity slumped with dramatic suddenness, and one began to hear persistent repetitions of Oscar Wilde's finicky gibe: 'he has elevated art to the level of photography'.

The Bloomsbury set in the nineteen-twenties were quite scornful about Frith . . . and yet, even they, at times, had doubts as to whether the creator of *Ramsgate Sands* (1854); *Derby Day* (1858); or *The Railway Station* (1862), *could* be so confidently written off. Lytton Strachey, referring to Victorian pictures in a letter to Virginia Woolf, remarked that 'perhaps there is really a baroque charm in them which will be discovered by our great-great-grandchildren, as we have discovered the charm of Donne, who seemed intolerable to the eighteenth century'.

Then, how about Roger Fry, who spent much of his life decrying the style of painting of which Frith was so consummate a master, and chattering about 'significant form', when speaking of the artists of the Hellenistic period? Listen to his truth-shattering *cri de coeur*: 'Would to God they had been Friths instead of Alma-Tademas.'

With Frith's *The Railway Station* (spirited up from the Royal Holloway College, Egham, to Piccadilly) occupying so prominent a place in the recent exhibition of Great Victorian Painting, sponsored by the Arts Council of Great Britain, at Burlington House, we suggest that the time is ripe for a fresh, unprejudiced look at Frith's contribution to British painting of the nineteenth century – and, indeed, of all time.

Acknowledgements

MY GREATEST DEBT IS TO FRITH HIMSELF; to his three volumes of *Autobiography and Reminiscences*, and to the intimate sidelights thrown on life in his household by his daughter, 'Cissy', whose *Leaves From a Life* (1908) and *More Leaves From a Life* (1911), issued under her married name, Mrs Jane Ellen Panton, usefully complement the details Frith supplies.

This debt will be apparent on practically every page of this work. And, closely following in importance, are two recent works by Mr Jeremy Maas: *Gambart: Prince of the Victorian Art World* (1976); and, *The Prince of Wales's Wedding (1865): The Story of a Picture* (1977), which have eased my path considerably and opened up several fruitful avenues of research. Most stimulating, too, has been Mr Christopher Wood's *Victorian Panorama: Paintings of Victorian Life* (1976), which contains several superb reproductions of Frith's paintings. His *Dictionary of Victorian Paintings* (1974), has since its publication become a standard work in what was, until it appeared, a somewhat inadequately researched field. It has never been far from my side.

Where both Mr Maas and Mr Wood have a distinct 'edge' on the art historian proper, I feel, is that they bring to their tasks as writers their vast experience as art dealers; and, I am deeply appreciative of the encouragement they have given me and the generous way in which they have shared their knowledge in my conversations with them. I feel sure my book has benefited greatly from all this.

Others to whom I am much obliged for advice on specific points, and for help in tracking down details about paintings include the staffs of the following dealers: Messrs. Richard Green, Ltd., 44, Dover Street, W.1; M. Newman, Ltd., 43a, Duke Street, St James's, S.W.1; Mr Roy Miles, 6, Duke Street, St James's, S.W.1; Captain Hollies-Smith of the Parker Gallery, 2, Albemarle Street, W.1, for advice on Frith engravings; The Leger Gallery, 13, Old Bond Street, W.1; Messrs. Thomas Agnew & Sons, Ltd., 43, Old Bond Street, W.1; Mr Jeremy Maas, 15a, Clifford Street, New Bond Street, W.1; and the Shepherd Gallery and

Christopher Wood, of 21, East 84th Street, New York City.

I am much indebted to the staffs of the following: the British Library; the Department of Prints and Drawings, British Museum; the Courtauld Institute of Art, and its companion, the Witt Library, Manchester Square, W.1; the City of Westminster Art Reference Library, St Martin's Street, W.C.2; the Paul Mellon Foundation's Library and Photographic Archive, Bloomsbury Square, W.C.1; to Sir Oliver Millar, Surveyor of the Queen's Pictures; to Miss Constance-Ann Parker, Librarian of the Royal Academy, and Mr Sidney Hutchinson, C.V.O., Secretary of the Royal Academy; the Victoria & Albert Museum and Library; the Tate Gallery, and many other galleries and institutions, which will be noticed separately in the captions to the illustrations.

The great auction-houses which have seen Friths appear and reappear down the years have been most helpful to us, as they are unfailingly at all times: Messrs. Christie, Manson & Woods, Ltd., of 8, King Street, St James's, S.W.1.; Sotheby-Belgravia, of 19, Motcombe Street, S.W.1, and Sotheby's of 34–35, New Bond Street, W.1.

Quite one of the most touching features of the catalogue of the Festival of Britain exhibition of Frith's work, staged at Harrogate and Whitechapel in 1951, was the manner in which the list of lenders was laid out in it. The list was headed, as was loyal and proper, by his late Majesty King George VI; but then, before listing the various private collectors and institutions who had lent paintings and memorabilia, there appeared a list of names, with an italicized description beside each name indicating their degree of relationship to the late W. P. Frith, R.A., viz.:

Miss Flora Hastings	*Grand-daughter*
Rev. Angelo Raine	*Grand-nephew*
Miss Grace Raine	*Grand-niece*
J. Raine, Esq.	*Grand-nephew*
Mrs Edgar Sheppard	*Grand-daughter*
Sir Godfrey Thomas, Bart.	*Great-grandson*

I found this list strangely moving; I still do. This quiet witness to the fact that whether Frith's work was in fashion or no, his descendants had never wavered in their conviction that the day would come round again when it would be thought neither singular nor perverse to hold the view that Frith had 'something', and merited serious reappraisal. As a result of this family loyalty to his memory many papers, sketches, personal letters, uncatalogued trifles and intimate mementoes have been preserved, I am certain, which might well have been lost or been hopelessly dispersed to creep back on to the market only in a piecemeal and

desultory fashion. We are much indebted to Diana, Lady Thomas, for the opportunity to examine many of these.

With the memory of one royal jubilee still pleasantly fresh in our minds, let us not forget, too, that Queen Victoria and the Prince Consort were amongst the earliest and most discriminating of Frith's patrons, although I never fail to be amused at the manner in which even Queen Victoria found herself outclassed as an art critic on one notable occasion by a small member of the royal household. They were viewing *The Prince of Wales's Wedding* (1865) in the Rubens Room at Windsor Castle, and the lad, lost in amazement before that impressive canvas, blurted out that he had never seen so many people in all his life. 'Don't be silly! Of course you have.' 'But not in a picture, mama.' History contains no record of a royal answer . . . and, we are not to be tempted in our foolishness into supplying one. What greater tribute was there ever paid to Frith: Master of the Crowd Scene?

William Frith

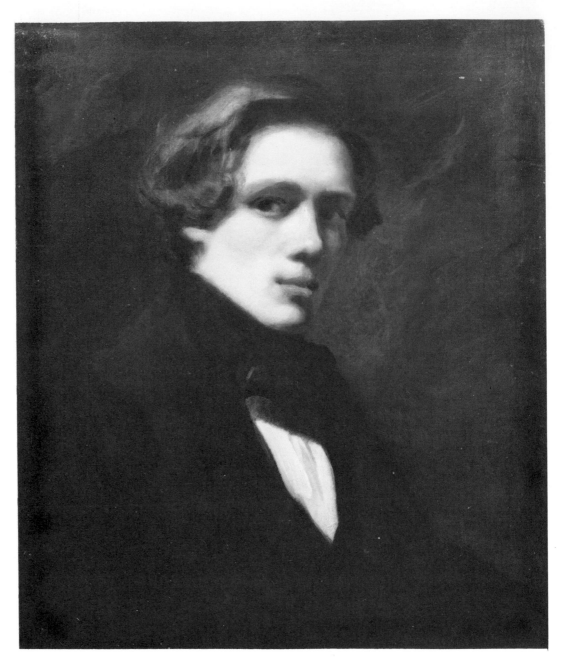

Self-Portrait.

1838. 23½ x 19 ins. Courtesy of the National Portrait Gallery, London.

A self-portrait of Frith at the beginning of his career, aged 19.

CHAPTER ONE

How Frith Began

WILLIAM POWELL FRITH (1819–1909), was born on 9 January 1819 in the little Yorkshire village of Aldfield, where his father was butler to Mrs Lawrence, then owner of Studley Royal, and his mother (formerly Miss Powell), the cook. Frith, senior, had a taste for art, and even late in life, Frith cherished many of his father's drawings, and the engravings he had so carefully collected. In 1826 the family moved to Harrogate where Mr Frith became landlord of The Dragon, a large, rambling old inn. The family then consisted besides his parents, of two brothers and a sister; and it was about this time that Frith's formal education, such as it was, began, at a school at Knaresborough, which, according to the artist himself, was run very much on 'Dotheboys Hall' lines, as were so many other establishments about that time in Yorkshire. One wonders if he ever discussed this early school of his with the creator of *Nicholas Nickleby* and talked over the 'original' of Mr Squeers.

His education continued at another large establishment, this time at St Margaret's, near Dover, which was kept by an amiable man named Temple, who, with a staff of ushers, boarded and educated nearly a hundred lads for £20 a year apiece. 'I really believe the education was quite extraordinary for the price paid for it,' writes Frith, 'but I cannot speak with authority, for I was only allowed a very little of it, the most of my time being taken up with my eternal copying in chalks, or lead pencil, with a little pen and ink for a change, from any good, bad, or indifferent print that fell in my way. I was placed in charge of the drawing-master, a Frenchman, with strict injunctions to allow me to do as I liked; and these injunctions received his careful attention, for he never interfered with me. Indeed, I soon found that his knowledge was as limited as my own; and it will scarcely be believed when we see the system, admirable as it is, which is now almost universally adopted in school-teaching, that in my early days bad drawings of impossible landscapes, and still more outrageous figures, were the only models placed before art students, who made bad worse, and only learnt that which they

had most studiously to forget when they began serious work.'

Frith remained two years at St Margaret's, but except for a little French, 'I learnt nothing.' There were several French boys at the school, and, as can be imagined with the memories of the Battle of Waterloo (1815) still so fresh in everyone's mind, they had an awfully rough time of it: 'frogs were sought and found in the ditches about St Margaret's; and also in the beds of French boys, who, on remonstrating, were accused of ingratitude for complaining of gratuitous gifts of their national food.'

Not unnaturally, Frith got involved in a fight with one of them ('if the affair could be dignified by the name of a fight'), but for some zany reason he had quite forgotten about it by the time he wrote his *Autobiography*: 'I placed myself in the posture of self-defence with which I was familiar from my usual source of information – engraving. My adversary, who was very angry, stared at my projected fists for a moment, then flew at me like a cat, scratching, kicking, and clawing in a very irregular manner; and it was only after a desperate struggle to free myself from his long legs and get my hair out of his clutches with some loss of it, that I was able to give him "one on his peepers" (to use the language of the P.R.), which produced a very black eye, and made him cry, and the battle was over. This was my first and last fight.'

In view of the fact that Frith was destined to become so 'literary' an artist and draw so many of his subjects from the approved eighteenth-century writers like Goldsmith, Addison, and Sterne, his description of those works of the imagination in which he revelled as a schoolboy are of more than passing interest: the novels of G. P. R. James, the romances of Mrs Radcliffe, but above all, the novels of Scott and Fenimore Cooper. His love for these last remained with him throughout life, but 'Mr James I have tried again; but the old love is dead, and now I wonder it was ever born.'*

When he grew up Frith found that most parents displayed a marked, and often angry opposition, to the choice of art as a career by any of their children, and so appreciated that his own parents had been exceptions to that rule. He never forgot the look of pain and disappointment on his father's countenance, when, having asked if he would like to go to London and learn to become a real artist, he had replied indifferently, that he did not care much about it, and thought he would rather become 'an auctioneer, or something of that kind'. The business

* Me, too. As a schoolboy going through a Dumas phase and reading *The Three Musketeers*, I devoured every novel about seventeenth-century France I could find. Stanley Weyman's *Under the Red Robe*, naturally, but also G. P. R. James's *Richelieu*. For those curious about yesterday's bestsellers, see S. M. Ellis, *The Solitary Horseman, or the Life and Adventures of G. P. R. James* (Cayme Press, 1927).

[22]

Contemplation.

Canvas. 12½ x 10 ins. Courtesy of Thos. Agnew & Sons, London.

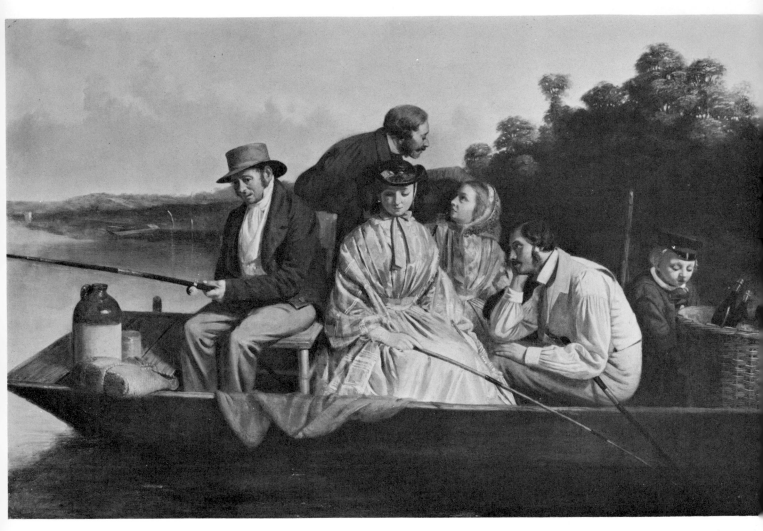

The Fishing Party.

$15\frac{1}{2}$ x $23\frac{1}{2}$ ins. Courtesy of Christies, London.

seemed easy to him as a fifteen year-old boy; and, what was more, he had heard there was money in it.

But, instinctively, and albeit he was probably a man with little formal education, Frith senior *knew* his son had it in him to succeed as an artist, and was not to be denied. He showed his lad's work to Sir Launcelot Shadwell, the Vice-Chancellor, who often visited and stayed at The Dragon, and learnt that if the boy was to follow the profession seriously he had best go to London and place himself under Henry Sass, who ran a school in Charlotte Street, Bloomsbury. After two or three years under him, and if he worked hard, he might become a student of the Royal Academy, where he would find ample and free instruction.

So it was that on a bleak March afternoon in 1835 Frith set out, with his father in charge of him, to make his fortune in London. The large portfolio of drawings his father had carefully selected to impress likely judges of his lad's prospects had been carefully placed 'in a folio covered with some material like tarpaulin, impervious to the weather'. The journey, which was made by stage-coach from Leeds, inspired no latter-day nostalgia in Frith's breast when he described it in later life:

'I think at the present time an express train requires little more than four hours to make the journey from Leeds to London – fifty years ago the quickest Royal Mail passage occupied never less than twenty-four hours, and sometimes, in snowy winter weather especially, much longer; and the weariness, the cramp, the sleeplessness of those terrible times can with difficulty be realized by the luxurious travellers of today.'

When the coach stopped at the Saracen's Head, on Snow Hill, close by St Sepulchre's, Holborn, each passenger alighted and scrambled for his luggage. From there, complete with that precious folio of drawings, the Friths moved off in a lumbering hackney-coach to Uncle Scaife's hotel in Brook Street, Grosvenor Square. Frith recalled that the coach had been driven by a man 'whose coat of many capes amazed me'.

In view of Frith's close associations later with Charles Dickens a slight interruption of our narrative will, we trust, be forgiven. The Saracen's Head was one of the finest examples of an old-fashioned London coaching inn and was pulled down in 1868. The site is covered now by the Snow Hill Police Station but a blue plaque there reminds us of the past glories of The Saracen's Head, which, it may be recalled, was used by Mr Squeers as his headquarters in town when rounding up victims for that awful Yorkshire school of his. The lads certainly got a grim foretaste of what the school-meals were likely to be from Mr Squeers' exchanges with one of the inn-servants: 'This is two penn'orth of milk, is it, waiter?' said Mr Squeers, peering into the jug. 'That's two penn'orth, Sir,' replied the waiter. 'What a rare article milk is, to be sure, in London!' said Mr Squeers with a sigh.

[25]

'Just fill that mug up with luke warm water, William, will you?' 'To the very top, sir?' inquired the waiter, 'Why, the milk will be drowned.' 'Serve it right for being so dear', replied Mr Squeers.

It had been agreed that Frith, senior, should take his lad's drawings and show them to Sir Launcelot's friend, Mr Phillips, R.A., and if he decided he had the makings of an artist, he was to go 'to this Mr What's-his-name in Bloomsbury to learn the business. If he thinks nothing of your drawings, I will apprentice you to Oxenham's in Oxford Street, and you can learn auctioneering.' In the event, Sir Launcelot being out of town, and there being no way of getting in touch with Mr Phillips, R.A., Frith senior felt momentarily cast down, his respect for the verdict of an R.A. being what it was. How very different from that of Uncle Scaife! 'R.A., sir! Why, they're as poor as rats, the lot of 'em. I know for a fact . . .'; and here he rambled off into a tale about a famous animal-painter: 'never paid for a dead swan, or a deer, or something, that he got from that place in the New Road; and what is more, he lodged for six weeks with a cousin of my 'ead-waiter, and ran away without paying a farthing. And that's the kind of thing you're going to bring your son up to!'

Maybe it was the scornful tone of this philistine brother-in-law of his that made the proud father even more determined to prove him wrong. He sought out a portrait and historical painter named Partridge whom he had discovered lived only a few doors away from Scaife's hotel. Partridge 'kindly allowed my father to leave the portfolio, telling him that the contents should be shown to the brothers Chalon, both Academicians, who were engaged to visit him in the evening.'

A few days later a happy father announced that they were strongly in favour of William starting his training as an artist. Years later, when he was successful and an Academician himself, Frith reminded Alfred Chalon of the advice he had given his old dad. Chalon looked nonplussed and could recall no details of their alleged meeting. However, since Frith had kept those youthful efforts of his which his father had brought to London, like votive offerings 'covered with some material like tarpaulin, impervious to the weather', he got them out to show the old artist. He looked them over curiously and carefully before turning slowly towards Frith. 'Do you mean to tell me that I advised that you should be trained as an artist on such evidence as this?' he said. 'I ought to be ashamed of myself!'

It turned out that Partridge, without bothering to consult either of the Chalons, had delivered judgement on the lad's talents himself . . . with the happy result, we know, that Frith found himself shortly afterwards enrolled as a student at Henry Sass's celebrated academy.

Like many artists who never quite achieve fame themselves Sass became a dedicated and inspired teacher. Besides Frith, other students of his included Sir John Millais (1829–1896), Edward Lear (1812–1888), and Abraham Solomon, the

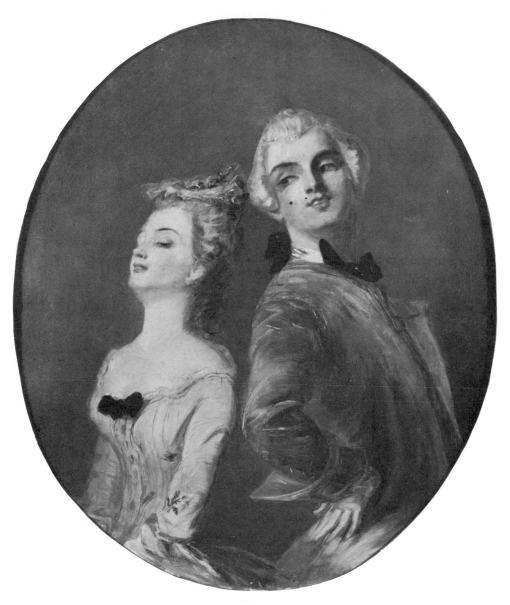

The Sidelong Glance.

1845. On a panel. 12¾ x 10½ ins. Courtesy of Christies, London.

The inscription on the reverse of this painting reads: 'painted by W. P. Frith and given to his brother Charles 1845'.

short-lived brother of Simeon Solomon. As a student of the Royal Academy's schools himself Sass had been the contemporary of Wilkie, Mulready, and Benjamin Robert Haydon, and many more less well-known to us now, but quite successful in their own time. All of them continued steady friends to Sass and sent on to him pupils they were often too busy to train themselves. Frith explains that, although Sass thoroughly understood the principles of art and could skilfully inculcate them to others, he never somehow got around to profiting by his own instruction!

He writes: 'His pictures were coldly correct, never displaying an approach to the sacred fire of genius, and almost always unsaleable. Under these circumstances, and warned by an increasing family, Mr Sass established his School of Art, at that time the only one existing. The duties of the school fully occupied the master's attention, leaving him time only to exhibit occasionally at Somerset House, and then only a small picture always called "A Study of a Head" and even this modest contribution was not allowed to escape the malignity of the critics, one of whom, in his general notice of one of the annual exhibitions, said: "Mr Sass continues to exhibit a study of something which he persists in calling a head".'

Frith found Sass's course of study very severe. The Master subjected those precious drawings, which his fond father thought so highly of, to the briefest of inspections before bodying forth the following eloquent dismissive: 'Ah, copies from Dutch prints! Shouldn't wonder if you turn out eventually to take to engraving. Whatever induced you to spend time in doing such things? Terrible waste. Can't have done you much harm if you can contrive to forget all about them. You will spend your evenings here in studying the compositions of Michael Angelo, and other great artists. You will find a large collection in my library, but no Dutch prints.'

Maybe Frith's *Autobiography and Reminiscences* is a bit rambling and diffuse for modern taste, and Neville Wallis's skilful condensation of it, *A Victorian Canvas* sufficient for the general reader today, but for those interested in the teaching methods of Frith's youth, his chapters on Sass and on the Royal Academy schools are amongst the most interesting and valuable in his books; and, although like most students he had a lively awareness of the foibles and shortcomings of his master he never ceased to remember him with respect and affection: 'Dear old Sass! I think he was wrong. It ought to have been, and it was, a consolation to him to feel that by instilling his admirable principles into others, he gave them ample means of achieving a success denied to himself. Many of his pupils became painters of high reputation, several were afterwards Academicians and one and all, I feel sure, would, if death had not sealed so many lips, endorse all I have to say in favour of the admirable art-teaching of Henry Sass.' Thus Frith, nearly sixty years later: a touching and pleasing tribute from a painter who achieved

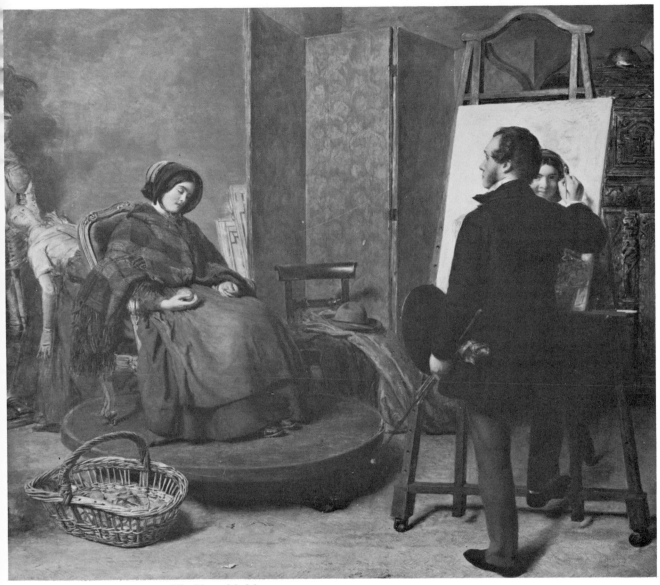

The Sleepy Model.

1853. 25 x 28 ins. Courtesy of the Royal Academy of Arts, London.

This is the picture that Frith presented to the Diploma Gallery (as was the custom) on his election to the Royal Academy in 1853. The model was intended to be laughing, but as Frith says in his *Autobiography:* 'After many attempts to rouse an expression that would help me make a laughing face, I found the worst of hindrances that can afflict a painter come upon me – my model fell fast asleep; and as nothing that I could say or do would keep her awake I abandoned the laughing subject and painted "The Sleepy Model", who now sleeps all day long in the Diploma Gallery.'

success in an often sensational fashion, with those everlasting rails around his pictures to protect them from a clamouring public, to an old master who never quite made it, but of whose devotion to the arts there could be no question.

Many amusing stories enliven the pages Frith devotes to his student days under Sass and in the Royal Academy's Life School. One of them neatly illustrates the relationship between Sir Edwin Landseer and his father, John Landseer, A.R.A., the eminent engraver. Even when his son had become highly successful, and was running a duchess as his mistress, John Landseer continued to address him as though he were still a small boy. Frith recalls an occasion when Sir Edwin, in his capacity as Visitor of the Life School, showed up: 'the only instance of his filling the office in my time'. He was then a very fashionable figure and much in demand at dinner-tables in high society and Frith recalls how he and his fellow-students wondered at seeing him so willing to spend an evening amongst them; not that he circulated amongst them, volunteered criticism or did anything, really. He simply sat and read a book: 'and one evening a very old gentleman in list slippers, with a speaking-trumpet under his arm, shuffled into the school'. It was John Landseer. His son rose to greet him, book in hand, whereupon the following exchanges passed between father and son. Since the old man's voice was loud and penetrating, the amused and slightly stunned assembly of models and students could hardly miss a word of these exchanges.

'You are not drawing, then; why don't you draw?'

'Don't feel inclined' (shouted down the trumpet).

'Then you ought to feel inclined. That's a fine figure; get out your paper and draw.'

'Haven't got any paper.'

'What's that book?'

'*Oliver Twist*.'

'Is it about art?'

'No; it's about Oliver Twist.'

'Let me look at it. Ha! it's some of Dickens's nonsense, I see. You'd much better draw than waste your time upon such stuff as that.'

— 2 —

When Frith left Sass he tried his hand at painting portraits of his Uncle and Aunt Scaife and some of their friends. An old gentleman saw one of these portraits, and being impressed, offered Frith £5 if he would make as good a likeness of him: 'I tried, succeeded, and received my first money reward for "work and labour done".' By a stroke of luck this man's daughter worked as a governess in a

Flowers.

1845. 45 x 40 ins. Courtesy of Christies, London.

Bargaining.

Oil painting on panel. 8¾ x 7¾ ins. Courtesy of The Leger
Galleries, London.

family in Lincolnshire, and when the head of this family, happening to be in London, saw the portrait of the governess's father, he, in turn, was struck and invited Frith to visit him: 'others, he had no doubt, would follow suit'. They did, whereupon the auctioneer side of Frith's temperament came into play and he smartly fixed his prices: £5 for a head; £10 for a kit-cat; £15 for a half-length, 'always the size of life'.

Frith was welcomed everywhere in Lincolnshire and kept busy working on various commissions in the homes of substantial gentlemen farmers: 'staying as long as my work lasted; sometimes flirting with the young ladies, who thought painting "Oh, such a beautiful art!" flattering their mothers – in their portraits, I mean – and I verily believe, making myself a general favourite everywhere.'

It was in this context that Dickens made his first impression on Frith. *The Pickwick Papers* were then coming out in serial form, taking the country by storm, and as each number appeared it was read aloud by the wife of one of his sitters, to beguile the tedium of the sittings (no radio then, of course). Her husband was a jolly, fat little chap, not unlike Pickwick himself – but, the wife? She was a solemn dame of a somewhat dismal, evangelical cast of mind, bereft entirely of any sense of fun; and yet, it was precisely this quality that rendered her Pickwickian readings so distinctly funny: 'Every sentence was uttered in precisely the same tones she used when she read morning and evening prayers, and I need scarcely say that that method of elocution, excellent as it was for the one purpose, became ludicrous in the extreme when adopted for the other.'

As an instance of this, Frith invites us to imagine what she made of the following chirpy observations of Sam Weller, delivered in the manner affected by the severest of Low Church clergymen: 'You would change your note if you know'd who was near you, as the hawk remarked to hisself with a cheerful laugh as he heard the robin-redbreast a-singing round the corner.' The solemn 'Amen' from her Pickwickian husband as she concluded was something Frith never forgot!

Looking back on this portrait-painting expedition into Lincolnshire, Frith felt he could have been given no better opportunity to prepare himself for his life as a professional artist. What surprised him, and continued to do so at the time he wrote his *Autobiography* was the curious difference in the merits of works done in consecutive order: 'I find some quite exceptionally well done, for so young a hand – good in drawing, colour, and character, others bad in every respect; but I have the satisfaction of feeling that in every instance I endeavoured to do my best, and undoubtedly I gained greatly by the experience. My work generally became much improved, and I would impress upon the young student the desirability of similar practice when attainable.'

In 1837, the year of the accession of Queen Victoria, who was destined to influence so notably the course of Frith's career, his father left Harrogate for

[33]

London to stay, as usual, at Uncle Scaife's hotel. He was a great sufferer from asthma; and, influenza being very prevalent just then, he was attacked by it and died after a few days' illness. Naturally, Frith felt his loss keenly: 'for, as so often happens, under a somewhat gruff manner there beat a warm and tender heart; he was a kind and loving father, and his loss at the comparatively early age of sixty was a lasting grief to his widow and children.'

It must have consoled the dear man, though, to die sure in the knowledge that the lad in whom he believed with such touching devotion, and whom he had rewarded as a child with sixpence for a drawing of a dog, and promises of more sixpences for future efforts, was already making his way as an artist.

How Frith Developed

AT FIRST SIGHT HARROGATE STRIKES US as one of those basically late Victorian and Edwardian towns, such as Sir John Betjeman rejoices in, and Sir Osbert Lancaster loves to delineate with affectionate irony, what with its statue of the Queen-Empress outside the North-Eastern Hotel and the verandaed shops opposite the station entrance. The outstanding feature of Low Harrogate is the dome of the royal hall, the social hub of the spa in its heyday, but since converted into a notable trade exhibition and conference centre.

Like so many of the old spas some of its most interesting buildings are its hotels. Frith's father had only recently become owner as well as landlord of The Dragon at the time of his death, and one of the first tasks his widow set herself was to negotiate its sale before settling in London and making a home for her sons. Their chosen careers (law and art) obviously meant that they would need to be London-based, at least until they got themselves established. They settled first at Uncle Scaife's private house in Brook Street, to which he had retired from the hotel business shortly after the death of his brother-in-law, and in discreetly affluent circumstances.

Frith writes: 'We were most kindly received, and there we remained till a house could be found for us. After much searching, we found 11, Osnaburgh Street, a house that suited us in every respect save one – there was no decent painting-room. But I made the best of a small back parlour, in which I painted my first compositions, and in which I passed some of the happiest hours of my life...'

In 1840, Frith, aged twenty-one, attempted a subject-picture in which figured two lovers in Spanish costume, inspired, he tells us, by a poem of William Cowper's, and, 'a reminiscence of a little *affaire de coeur* of my own'. It was sent to the Liverpool Exhibition and found a buyer there, who gave £15 for it, as well as a friendly mention in the *Art Union*: 'The young painter has given proof that he thinks whilst he labours.'

Polly Peachum.

1875. 40 x 29¾ ins. Courtesy of Sotheby-Belgravia, London.

Frith's interpretation of the heroine of Gay's highly successful play *The Beggar's Opera*.

Scott being a great favourite of Frith's he decided to illustrate the following passage from the *Lay of the Last Minstrel*:

> Full slyly smiled the observant page,
> And gave the withered hand of Age,
> A goblet crowned with rosy wine,

which the old man certainly needed as he unfolded his prolix tale to the Duchess!

Then he tackled another and larger composition from Scott's *The Heart of Midlothian* showing the interior of the church, with Madge Wildfire dragging Jeanie Deans up the centre aisle, to the amazement of the congregation. The 'auctioneer' in Frith led him to tell us what happened to the picture: it became the property of an artist-friend who never paid for it, because, as he informed him, he could not sell it and had to swap it for a piano for his sister, 'and the piano hasn't got a note to its back!' Follow *that*!

1840 also saw him exhibit his first painting at the Royal Academy, where he was to continue to exhibit until the twentieth century. His first subject was again literary in its inspiration: 'Malvolio, cross-gartered before the Countess Olivia.' By a happy coincidence his friend, Daniel Maclise (1806–1870) also had a picture on the same subject, 'now in the National Gallery, of which it is, I think, an ornament; where mine is, I know not, but it could scarcely be considered an ornament anywhere.' In a sly aside on the subject Frith adds that it was bought for £20 by a dealer who went bankrupt immediately after!

Buried away in the diffuse pages of the *Autobiography* there is also one of those delightfully human touches which reward its patient readers. As a young man without a friend at court Frith cultivated the Royal Academy's porter, Williamson, and inveigled him into letting him know if his picture got in. A pencil note from him duly arrived in Osnaburgh Street: 'Sir, you are hung *safe*', whereupon there was joy in the Frith family, 'and we had oysters for supper'.

Next year he returned to his beloved Scott for his Royal Academy offering: his chosen subject was an interview between Leicester and his Countess Amy, when, at the end of one of the wicked Earl's stolen visits to Cumnor Place, he is anxious to free himself from the lady's importunity. He visited Knowle House for this painting and made studies of King James's bed, and other details which appear in the picture, but ruefully confessed later that, 'as human beings are more difficult to render than chairs and bedsteads, my picture was more admired for the still-life objects than for the living creatures'.

The example set by Daniel Maclise in illustrating *Gil Blas* and *The Vicar of Wakefield* caused so many Vicars and Gil Blas's to crowd the walls of exhibitions

[37]

The Love Token.

1854. 17½ x 14 ins. Courtesy of The Leger Galleries,
London.

Exhibited at the R.A. in 1854, the International Exhibition
in 1862, and the Royal Academy Winter Exhibition in 1911,
this painting illustrates the scene from Scott's *The Bride of
Lammermoor* when 'Lucy Ashton cut the ribbon asunder,
and detached the broken piece of gold . . . With haughty
courtesy she delivered both to Ravenswood.'

Portrait of Amy Robsart and Janet.

1870. 12⅜ x 10¼ ins. Courtesy of The Leger Galleries, London.

This painting illustrates the following passage from Scott's *Kenilworth:* 'They went to the withdrawing apartment accordingly, when the Countess playfully stretched herself upon a pile of Moorish cushions, half-sitting, half-reading, half-wrapped in her own thoughts, half-listening to the prattle of her attendant.'

that Thackeray, in that mock-angry way of his, threatened in *Fraser's Magazine* that he would never look at any more pictures in which those tiresome individuals appeared, much less write about them. He could not even bother to mention Goldsmith's paragon of virtue by name and cultivated the habit of referring to him simply as 'the V – r of W – d'.

By a curious irony, though, it was Frith's delineation of the scene in which Mrs Primrose makes her daughter and Squire Thornhill stand up together to see which is the taller, 'bought on the Private View day by an Art Union prize-holder, Mr Zouch Troughton, who is now my very old friend', and his quest for ever-fresh literary subjects which led Frith to read Dickens in his search for themes the critics might be a shade less scornful about: 'but at that time the ugliness of modern dress frightened me, and it was not until the publication of *Barnaby Rudge* and the delightful Dolly Varden was presented to us, that I felt my opportunity had come, with the cherry-coloured mantle and the hat and pink ribbons.'

These pictures easily found purchasers, albeit for sums Frith felt were small enough: 'The laughing Dolly, afterwards engraved became very popular, replicas of it being made for Dickens's friend, John Forster, and others.' Since Frith had, up to that time, known and admired Dickens only through his books, it may well be imagined what excitement there was in the Frith household when a letter arrived from Dickens, addressed from 1, Devonshire Terrace, York Gate, Regent's Park, and dated 15 November 1842 requesting him to 'paint me two little companion pictures; one a Dolly Varden (whom you have so exquisitely done already), the other, a Kate Nickleby'.

Frith recalled how he and his mother cried over that letter, 'and the wonder is that anything is left of it, for I showed it to every friend I had, and was admired and envied by all'. He made innumerable sketches of Kate Nickleby until he finally settled for a scene at Madame Mantalini's where Kate figures as a work-woman, the point chosen being at the moment when her thoughts wandered from her work, as she sat sewing a ball-dress spread upon her knees.

Dolly Varden was represented tripping through the woods, and looking back saucily at her lover, and as we see her in the delightfully rearranged gallery of Constables and nineteenth-century paintings at the Victoria and Albert Museum. The pictures were finished and Dickens informed that they awaited his inspection: 'See me then in hourly and very trembling expectation of a visit from a man whom I thought superhuman.'

When he arrived Frith beheld a pale young man with long hair, a white hat, and a formidable-looking stick in his left hand. His right hand Dickens extended to the artist, 'with a frank cordiality, and a friendly clasp, that never relaxed till the day of his untimely death'. The pictures were on the easel and Dickens sat down to examine them as Frith hovered around nervously awaiting the verdict

Dolly Varden.

1876. 17 x 13 ins. Courtesy of the Tate Gallery, London.

A smaller, less well-known version of Frith's famous portrait of 'The Laughing Dolly' from Dickens' *Barnaby Rudge*. See also Plate Eight.

Back to Back.

1867. 13½ x 10 ins. Courtesy of Sotheby-Belgravia, London.

This shows the scene in Goldsmith's *She Stoops to Conquer* in which Mrs Hardcastle asks her son Tony and Miss Neville to stand back to back to see which is the taller. Tony hits Miss Neville on the head with the back of his own whilst Mrs Hardcastle and Mr Hastings (Miss Neville's lover) look on.

Measuring Heights.

1863. 10¼ x 12¾ ins. Courtesy of The Leger Galleries, London.

Another 'back to back' measuring scene, this time from *The Vicar of Wakefield*.

of the Inimitable. 'All I can say', said Dickens, to his intense relief, 'is, they are exactly what I meant, and I am very much obliged to you for painting them for me . . . Shall you be at home on Sunday afternoon? I should like to bring Mrs Dickens and my sister-in-law to see how well you have done your work. May I?'

Frith, feeling like a puppy with two tails, was standing at his front-door when Dickens and his party arrived that Sunday afternoon in a carriage which Dickens drove himself. The excitement of seeing 'Boz' turning up at his front door in a carriage with a bright steel bar in front giving the vehicle a very striking appearance, to a young artist not at all accustomed at that time to having patrons arriving in curricles at his home was reward enough, albeit he was pleased also to be handed Dickens's cheque for £40 for the two pictures.

The 'auctioneer' in him did not fail to remind him, though, to mention in his *Autobiography*, that at the sale of the novelist's effects after his death at Christie's, Dolly and her companion fetched 1300 guineas. Dickens died on 9 June 1870, but already, by 24 June, thirty-seven of his pictures and drawings, together with china, glass, silver, clocks, and objects arrived at Christie's and a catalogue was quickly prepared for the sale which was staged for Saturday 9 July at one o'clock. An interesting account of the Dickens sale by Christopher Wood is to be found in *Christie's Review of the Year 1969/70* (Hutchinson 1970).

Dickens's artist-friends included Stanfield, Maclise, Frank Stone, Wilkie, Landseer, C. R. Leslie, Frith, and E. M. Ward. He commissioned work from many of them, and they in turn presented him with pictures and sketches. Since almost every item in the Dickens sale had a personal-associative value the prices realized in this sale were well over average. For example, a Mr Notage paid 120 guineas for Dickens's favourite raven, stuffed in a glass case, and described simply as 'The Grip' of *Barnaby Rudge* fame.

Frith's associations with Thackeray, were, alas, much less happy. Since Thackeray had written a charming criticism of a picture of Frith's under the pseudonym of 'Michael Angelo Titmarsh' in *Fraser's Magazine*, Frith was eager to meet him, and did do so in a club called The Deanery in Dean Street, Soho, where he was taken by a companion who assured him Thackeray was likely to be found there; and so he was, but not in the dining-room. They found him in the smoking-room and in the centre of a convivial party who were listening to Francis Mahoney (1804–1860, 'Father Prout') singing a song. Frith, who was a young man at the time and had only just become an A.R.A. (1844), sat in awe-struck silence listening to the brilliant talk of the literary crew. Then someone called upon Thackeray for a song and he obliged with one of his own composition, involving some characters rejoicing in the names of Gorgeing Jack and Guzzling Jimmy. No sooner had the applause died away than Thackeray, in a chaffing tone, turned and said: 'Now then, Frith, you d—d saturnine young Academician, sing us a

Merry-making in Olden Times.

1847. 20 x 33¼ ins. Courtesy of Christies, London.

Frith made several replicas of this popular work, the
original of which is in the Proby Collection at Elton Hall.
There is also a small oil sketch of it in the Victoria and
Albert Museum, London.

Coming of Age in Olden Times.

1849. 50 x 79 ins. Courtesy of Christies, London.

Repainted in 1859, the background to this picture is based
on Hever Castle and Heslington Hall, near York.

song!' Frith was taken completely unawares and looked distinctly flustered and dumb. Thackeray sensed that he had an easy target and added: 'I tell you what it is Frith, you had better go home; your aunt is sitting up for you with a big muffin.'

Frith *did* go home, and rested content thereafter with admiring Thackeray's work; and, although thereafter they often met in society Frith studiously avoided ever giving him another opportunity to make fun of him. On the whole, I agree with Frith 'that such attacks on an inoffensive stranger were very poor jokes, and even after a long lapse of time I feel humiliated and pained in recalling them'.

It was all very sad since Thackeray had thought seriously of becoming an artist, and in the event did illustrate many of his own books as well as contribute an immense number of drawings to *Punch*. In one of his 'Roundabout Papers' he recalled how he had ornamented the leaves of his class-books at Charterhouse with caricatures of his masters and schoolfellows, and embellished his copy of *Don Quixote*, Horace Walpole's Gothic novel, *The Castle of Otranto* (in which there is an entertaining sketch of Manfred holding the door against Matilda), *Robinson Crusoe, Joseph Andrews*, and many other tales: 'O Scottish Chiefs, didn't we weep over you! O Mysteries of Udolpho, didn't I and Briggs (Minor) draw pictures out of you! Efforts feeble, indeed, but still giving pleasure to ourselves and our friends. "I say, old boy, draw us Vivaldi tortured by the Inquisition", or "Draw us Don Quixote and the Windmills", amateurs would say to boys who had a love for drawing.' Many of these drawings done at school have been preserved and are well-known to Thackeray's admirers.

Meanwhile Frith persevered with his reading and found inspiration therein which resulted in such paintings as *Thornhill Relating his London Adventures to the Vicar's Family*. Thackeray's strictures on 'the V—r of W—d' industry receives amusing, if unconscious, confirmation in Frith's *Autobiography* where he tells us that his 'Vicar' subject appeared together in the Royal Academy exhibition of 1842 with a small one depicting a confrontation between John Knox and Mary, Queen of Scots: 'In the same Exhibition as my "Vicar of Wakefield" and "John Knox" was *another* subject from the "Vicar" and *another* "John Knox"; the former being an exquisite picture called *The Whistonian Controversy* (by Mulready), and the other, *Knox Reproving the Ladies of Queen Mary's Court* (by Chalon).'

When Creswick, the landscape-painter, advised Frith to put his name forward for nomination as an A.R.A., he said he must be joking: 'what chance have I of being made an Associate?' 'Not any', Creswick replied, 'but I would advise you to put down your name, so as to familiarise the Royal Academicians with it.' He was right, and in the event, Frith was elected an A.R.A. at twenty-five.

Frith's rising fortunes were by this time attracting notice, and Turner observed of his principal Royal Academy offering of 1847, *An English Merry-Making*, that

[47]

'Widow Wadman Lays Siege to my Uncle Toby.'

1865. 29¾ x 20½ ins. Courtesy of the Tate Gallery, London.

An enchanting rendering of the scene thus described by
Sterne: 'When the attack was advanced to this point the
world will naturally enter into the reasons of Mrs Wad-
man's next stroke of generalship: which was to take my
Uncle Toby's pipe out of his hand as soon as she possibly
could; which under one pretence or other, but generally
that of pointing more distinctly at some redoubt a breach-
work in the map she would effect before my Uncle Toby
(poor soul) had well marched above half a dozen toises
with it . . .' (*Tristram Shandy*)

it was beautifully drawn, well composed and well coloured. It became very well known through a beautiful engraving made of it by William Holl. Frith states that 'when Turner overpraised my picture' he had never spoken to him, and had seen him only on varnishing days at the Academy.

Frith kept reading, Sterne, Goldsmith, Molière, Cervantes, Addison and Steele's *Spectator* essays – and, Shakespeare. Of this last Frith held no very great opinion himself: 'I have never meddled with Shakespeare without regretting my temerity, for though I have painted several pictures from different plays, I cannot recall one that will add to my reputation.'

His preoccupation with events and themes drawn from the past and from literature in these early days, was, he confides, dictated largely by his fear of modern life subjects. 'The hat and trousers pictures that I had seen attempted had all been dismal failures; and I felt sure, or thought I did, that unless a subject of tremendous human interest could be found – such an interest as should make the spectator forget the dresses of the actors in it – modern life was impossible; and as no such subject presented itself, I took refuge in bygone times; and during my seaside holiday in 1848, I made a sketch for a picture to be called *Coming of Age*, the period being about that of Elizabeth. The scene is laid in the quadrangle of an old English mansion. On steps leading to the house stands the young heir, listening to an address of congratulation read by an old man, who may be the parish clerk. Groups of villagers, tenants and others, surround the reader, several of whom bring gifts. An armourer presents a helmet decked with flowers; a falconer's boy is in charge of two dogs (deer and blood hounds); an old woman, who may have been the young lord's nurse, with clasped hands invokes a blessing upon him; and in the background peasants and neighbours are regaling on an ox roasted whole, that affords a satisfactory *pièce de résistance*. Some noble relatives of the young heir stand behind him.'

Frith's authorities for the background were Hever Castle, and Heslington Hall, near York. The picture, which was well engraved, became so popular that Frith did not feel that much further description than he gave (and we have just quoted) was required. Work on it began on one of the last days of September 1848 and finished in April 1849. Thackeray again, in a review of the 1849 exhibition in which it appeared: 'Why, when a man comes of age, it should be thought desirable that he should come of the age of Elizabeth?' Whilst another critic, who, maybe had missed lunch, suggested that it would have been better if such an ill-drawn idiotic youth as Frith represented had been cut off in infancy and so been prevented from coming of age at all!

Large and lucrative as Frith's practice became during his first ten years as a professional painter he felt that he was in danger of getting into some kind of rut, and, reading between the lines, we gather that although the 'auctioneer' side of

[49]

Frith found little to complain of as regards his financial returns the artist in him was less satisfied. Little did he realize when he set out on another summer holiday – to Ramsgate, this time, and in 1851, that he would return from it with his problem resolved; his true form as an artist discovered.

CHAPTER THREE

Ramsgate Sands (1854)

MILLAIS COMPLAINED TO DR URQUHART that 'artists have to wrestle today with the horrible antagonism of modern dress; no wonder, therefore, that few recent portraits look really dignified. Just imagine Vandyke's *Charles I* in a pair of check trousers.' Quite so. Frith felt much the same way, which is why he concentrated so much in his early years on those everlasting themes culled from Goldsmith and other favourite eighteenth-century authors in which the characters obliged the painter by wearing the picturesque habiliments of an earlier, more gracious day.

Yet time was to prove the truth of William Bell Scott's prophecy: 'Frith will be much thought of in some future day because he has illustrated the age in which we live.' Frith spent the summer holiday of 1851 at Ramsgate, where, weary of costume-painting, he decided to try his hand at depicting modern life, 'with all its drawbacks of modern dress'. The variety of character on Ramsgate Sands attracted him; all sorts and conditions of people were to be found there: 'pretty groups of ladies were to be found, idling, working and unconsciously forming themselves into very paintable compositions'.

Frith's diary entries inform us that on 4 September he was, 'On the Sands sketching'; 'Sept. 10. Sketching on the sands till one.' Each succeeding day was occupied in making slight drawings of details. On 14 September he writes: 'Made pencil-drawing of Ramsgate Sands. I wonder if I shall make anything of it – who knows?'

The pencil-drawing was but preliminary to a very careful oil-sketch, 'in which colour, light and shade, and to some extent character, were determined'. His diary entries continue thus:

'Sept. 30. Began idly to make a sketch from Ramsgate Sands, which, if successful, will considerably alter my practice.

'Oct. 2. An idle sort of day, thinking, and arranging for "*Ramsgate Sands*".

[51]

'Oct. 3. Finished outline of "*Sands*", an extensive business; out early to Great Exhibition [i.e. of 1851 in Hyde Park].

'Oct. 21. Began to paint in sketch of "*Ramsgate Sands*"; did one group.

'Oct. 22. Again at work; did another group.

'Oct. 24. Again at sketch of "*Ramsgate Sands*"; progressing with it.

'Oct. 25. Finished group of girls reading, and a man selling toys.

'Oct. 28, 29. "*Ramsgate Sands*"; worked, but did little good.

'Nov. 1. Worked all day on "*Ramsgate Sands*"; fear I am spending more time on it than it is worth.

'Nov. 3. Sketched the widow and her friends.

'Nov. 4. The green lover and over principal group.

'Nov. 8. Sea-shore and figures.

'Nov. 11. All day on background of "*Sands*"; fear it will not do. Disagreeable at present.

'Nov. 13. Again on background of "*Sands*"; finished it; liked it much better.

'Nov. 14. Finished sketch.

'Nov. 15. Ward saw sketch, and seemed struck with it.'

Ward and Egg were the first artists to whom Frith showed his sketch, and both were impressed. Egg strongly advised him to paint a large picture from it. With certain interruptions due to having to work on odd portraits and small commissions Frith continued work on *Ramsgate Sands* until the summer when he returned to Ramsgate to ensure that he got his details right. Frith explains: 'Photography was in its infancy at that time; I had therefore to rely on my own drawings of houses, cliffs, and bathing-machines; for though photography, or, as it was then called, "Talbotyping", was tried, the result was useless. The sea troubled me greatly . . .'

6 September saw him at work 'at the sea, and perfectly at sea' since he could no more paint it 'than I could fly to the moon'. He began wondering if all the time he was spending on the picture would repay him. Leech, who called on him on 27 September and saw the picture, predicted that it would prove 'a great hit'. Frith's comment: 'Who can tell?'

Back in town he worked pretty constantly on the picture on which he felt so much would depend, and had at first hoped that it would be ready for the Royal Academy exhibition of 1853, but as time went by he realized that he would require more time for finishing properly. In the event it was to prove the sensation of the following year's exhibition. But, we anticipate.

The best part of 1853 was devoted to what Frith refers to in his diary as 'Sands' and his problems in finding suitable models for it. 'I noticed an incident of pretty frequent occurrence, which I determined to introduce into the background of my picture', Frith writes. 'A couple of men were joint proprietors of a "happy family" consisting of cats and mice, dogs and rabbits, and other creatures whose natural

Making a Posy.

9¼ x 6⅞ ins. Courtesy of Thos. Agnew & Sons, London.

It is clear from the description of the painting in the *Art Journal* (1856), that the version of this picture in the City Museum and Art Gallery, Birmingham (12¼ x 16½ ins.), or a painting based on it, was one of Frith's Royal Academy offerings that year.

A Wise Pet.

23 x 19 ins. Courtesy of Sotheby-Belgravia, London.

instincts had been extinguished so far as to allow of an appearance of armed neutrality, if not of friendship, to exist amongst them. When the cat played with the mice, and had allowed canaries to peck it without resenting the liberty, a hare was made to play upon a tambourine, and during the finale, the proprietor's friend and assistant on the drum made the usual collection. The drummer wore a wonderful green coat; he was very ugly, but an excellent type of his class. As I made up my mind to introduce the whole of the show, taking the moment of the hare's performance as the chief point it was necessary to enter into negotiations with the proprietors. I had found, as I expected, that they hailed from London; and I also found that they would sit, and the animals would sit, if they were sufficiently well paid for doing so.'

The chief proprietor turned out to be a Mr Gwillim, of 32, Duke Street, Tower Street, Waterloo Road. He came to see Frith in London and a day was fixed for his first sitting, but it was late December, and the fogs had 'done' for the old seaside trouper, as the following letter from him to Frith makes clear:

> *Dec. 23, 1853.*
>
> *Sir,*
> *I ham sorry I Cannot as attend on you to-Day. My limbs*
> *is so Bad that I thout I Could not Do you justice, and It Being*
> *so Wet and Fogger I thout it Wol Make no Difference to you*
>
> I Remain you
>
> MR. GLLM.
>
> *At 32, Duke Street, Tower Street,*
> *Waterlew Road.*

However, the fogs, even in those *Bleak House* days did finally lift and Gwillim surfaced with the hare in Frith's studio: 'worked hard and painted him and the hare, the birds arranged for tomorrow . . . Dec. 31. A good day at birds, cages, etc.; finished them pretty well. Paid the man 30s., and bade him adieu.' I wonder how many visitors to the Royal Academy recognized the old chap and his pets when the painting went on show?

This brings us to a consideration of the painting as a slice of Victorian social history, and here we are very much in luck, since in the September 1956 issue of the *Architectural Review* we find that Dr Nikolaus Pevsner has devoted a feature to the topographical elements in the painting so often overlooked by those of us who get caught up in contemplation of the many incidents in the foreground and the minute details of costume. He suggests that the best proof of Frith's accurate sense of atmosphere, mood and character is the architectural parade at the back of *Ramsgate Sands*. He writes:

[55]

'This procession of modest buildings is curiously English, in its total absence of uniformity, even of level, and its emphasis instead on a general sympathy of a building with its neighbours, and of groups of buildings with each other. *Ramsgate Sands* was painted in 1853. Ramsgate had been developed as a seaside resort chiefly during the first half of the century. The key to the buildings is this: The Clock Tower in Pier Yard on the extreme left dates from 1815. The engineer in charge of work on the pier was Rennie. To the left of the Obelisk is the Royal Hotel, built in 1844–45. The Obelisk commemorates the visit of George IV to Ramsgate, September 21, 1821, to embark for Calais and Hanover, and his return during the following November. It was designed by John Shaw, architect of St Dunstan's, Fleet Street. To the right of the Obelisk is the Harbour Master's and Customs House of 1800–1815. The castellated building dates from shortly after 1823 and is known as Pier Castle. At its feet are offices and cells of the Harbour Police. Kent Terrace, in the centre of the picture, was built in 1833–37, the scheme being no doubt encouraged by what was being done in other seaside places at the same time. Towering above Kent Terrace is Albion Square (now Albion Place), begun in 1789. Albion was especially popular for street names, etc., at that time (compare for instance with Albion Hotel, Brighton, built in the twenties). To the right of Albion Square follow East Cliff House, *c.* 1823, and Well Crescent, 1819–22. The designs seem to be by Pilcher Longley, a carpenter, and one Smith, a builder.

'Today of these buildings the following no longer exist: the Royal Hotel, which was pulled down in 1938 and set back some twenty feet; and the Harbour Master's house and office, the Customs House, and the offices and cells of the Harbour Police, which were all demolished in 1895 to widen the road leading to the London, Chatham and Dover Railway.'

In a footnote to his invaluable article Dr Pevsner adds that the information given in it was kindly checked by B. C. Darley, the Borough Librarian of Ramsgate at the time, and incorporates fresh information supplied by him.

Up to what Frith terms the *Ramsgate Sands* time he found little difficulty in selling innumerable small works which had been commissioned, but, naturally, his larger works produced more or less on speculation, proved necessarily expensive in view of their size and the time occupied in completing them. It was his habit to leave a large loophole for escape for would-be purchasers who were not prepared, when a picture was done, to put their money where their loud, confident mouths had been when they urged the painter on at earlier stages, albeit they overwhelmed him with encomiums in respect of his skill, virtuosity, commendable industry, and the rest.

He mentions how some collectors had found him out about this period, and how, according to their own testimony, so readily and fulsomely volunteered, price was of no consequence to them. One of them who saw his early sketch of

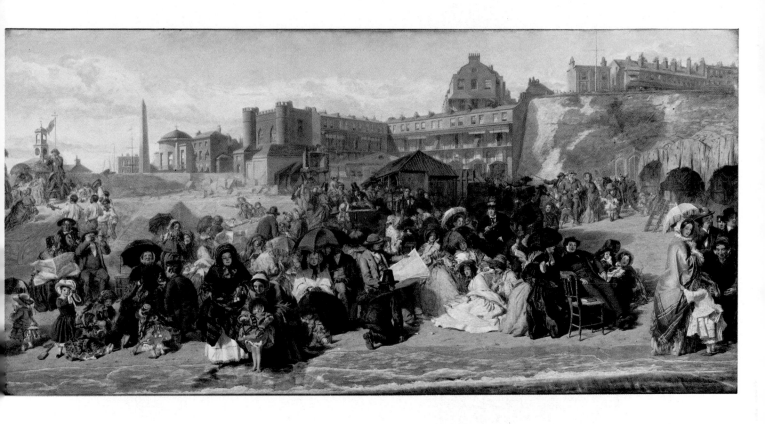

PLATE ONE : *Ramsgate Sands*

1854. 30 x 60¼ ins. Copyright reserved.

First exhibited at the R.A. in 1854 as 'Life at the Seaside'.
Frith sold it to a dealer for 1000 guineas, who subsequently
sold it to Queen Victoria at cost price whilst retaining
exhibition and engraving rights on it amounting to £3000.
The picture now hangs in Buckingham Palace.

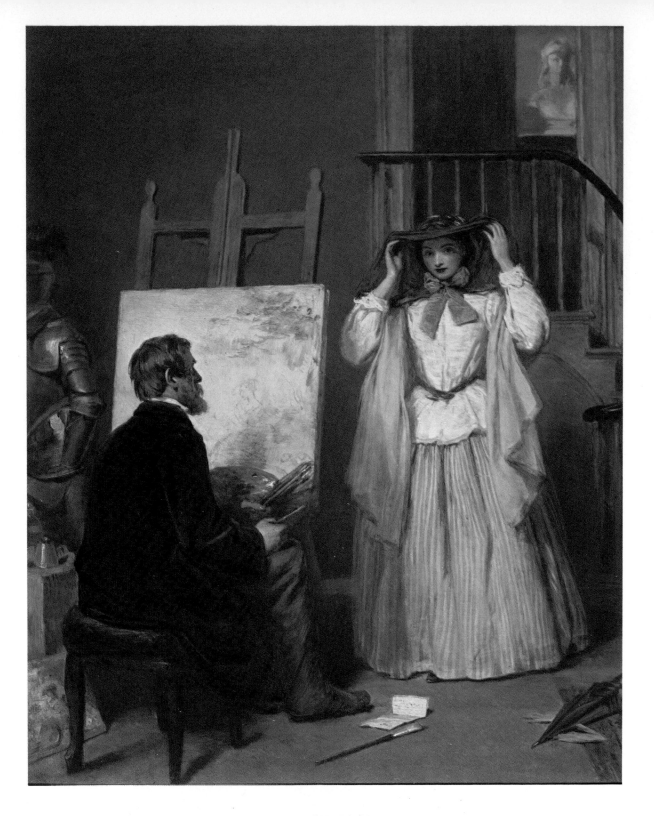

PLATE TWO: *The Artist and His Model*

1860. On a panel. 13 x 10¼ ins. Collection: Thos. Agnew &
Sons, London.

Recently featured in an exhibition of Victorian painting at
Thomas Agnew & Sons, London (1975).

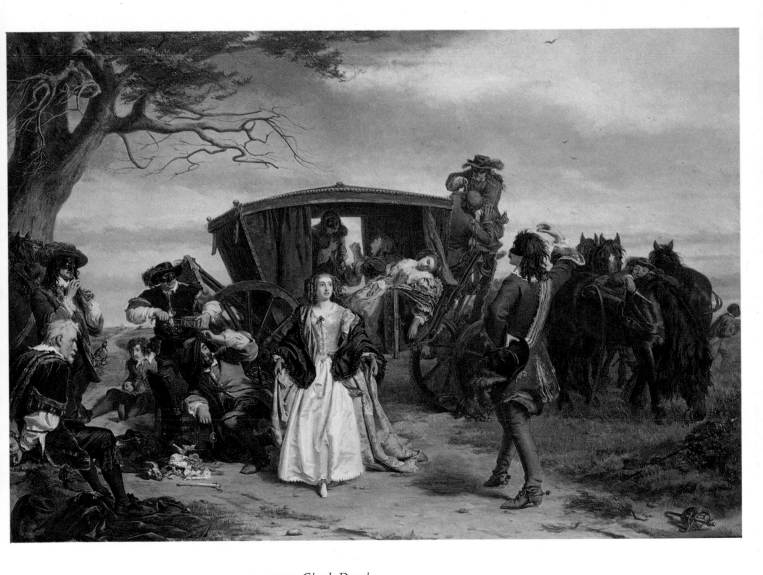

PLATE THREE: *Claude Duval*

1860. 30 x 40 ins. Collection: Sotheby-Belgravia, London.

This painting illustrates a passage in Macaulay's *History of England*: 'It was related how Claude Duval, the French page of the Duke of Richmond, took to the road, became captain of a formidable gang, and had the honour to be named first in a royal proclamation against notorious offenders; how at the head of his troup he stopped a lady's coach, in which there was a booty of four hundred pounds; how he took only one hundred, and suffered the fair owner to ransom the rest by dancing a coranto with him on the heath.' Frith painted another, smaller, version of this scene in 1886.

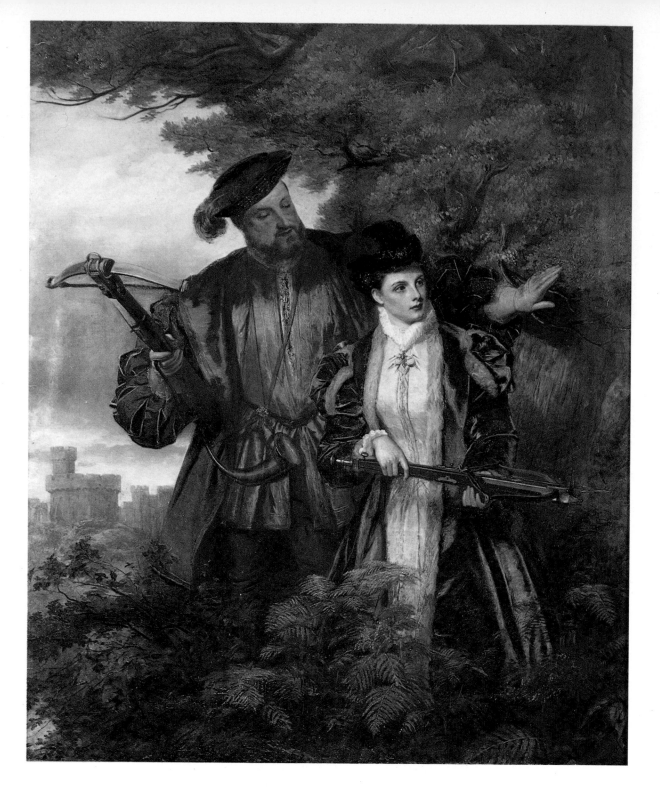

PLATE FOUR: *Henry VIII and Anne Boleyn Deershooting at Windsor.*

1872. 48 x 39 ins. Collection: Sotheby-Belgravia, London.

First exhibited at the R.A. in 1872.
A further appreciation of this painting can be acquired by reading Harrison Ainsworth's novel *Windsor Castle*.

Sands, asked its price, the proposed size, and a variety of other questions. Yes, he was 'perfectly delighted' with the subject, and the size was all right, too. Could he have the first offer for it when it was done? The gentleman in question was a perfect stranger to Frith, but as he happened to be a friend of a friend of Frith's, he imagined he was all right.

However, when Frith mentioned his name to a fellow-artist on a visit to his studio, he remarked that he thought Frith was making a mistake since the same man had been in *his* studio, and told him that he had 'seen your sketch of *Ramsgate Sands*, and (you won't mind my telling you, will you?) he said he wondered how anybody in his senses could waste his time in painting such a tissue of vulgarity, and that he wouldn't have such a thing on his walls'. After a repetition of this sort of thing from half-a-dozen would-be Maecenes-of-the-Arts, Frith decided to ignore the oft-repeated advice of well-meaning friends to have nothing to do with dealers and sold it to Messrs. Lloyd for 1000 guineas.

One of Frith's would-be patrons backed down on the grounds that his picture 'wanted *something*'. Frank Stone, who happened to be around in Frith's studio at the time, quipped: 'What do you say to a balloon, sir?' pointing to the sky on the canvas. 'Would *something* of that kind finish the picture?'

The painting duly went on show in the Royal Academy exhibition of 1854, but what happened then can be best left in Frith's own words: 'April 28. – Drove to R.A. at a quarter to twelve; the Royal family came. Eastlake presented me to the Queen. She was delighted with the *Seaside*. Wanted to buy it – found she couldn't, and gave me a commission for a similar subject. Everybody likes it. I find myself and Maclise the guns this year.'

Daniel Maclise (1806–1870), the friend of Dickens and Frith, had that year produced his huge oil painting of *The Marriage of Strongbow and Eva*, which is now in the National Gallery of Ireland, Dublin. For details of it, see the Arts Council of Great Britain catalogue produced by Richard Ormond to coincide with the Maclise exhibition staged at the National Portrait Gallery (3 March–16 April 1972), and later at the National Gallery of Ireland, Dublin (5 May–18 June 1972).

Frith retired from the presence of royalty as soon as he could do so with propriety, 'but not before I had experienced the truth of what I had often heard, namely, that the Prince Consort and the Queen knew quite as much about art as most painters; and that their treatment of artists displayed a gracious kindness delightful to experience.

'Sir C. Eastlake, whose duty it was to attend the Royal party through the entire Exhibition, left them, and came to me whilst I was standing among the rest of the Council, to inquire into whose possession the *Life at the Seaside* – as it was called in the catalogue – had fallen. "Bought by a picture-dealer", said I, "who for a

profit would sell it to her Majesty or anybody else." Eastlake returned to the Royalties and conveyed my intelligence evidently, for I could see a slight shrug of the Royal shoulders, which said quite plainly, "Picture-dealer! Outrageous profit, of course." A few days solved the question, for Messrs. Lloyd, hearing of the Queen's desire for the picture, opened up communication through the usual channel; the result being the acquisition of the picture by the Queen for the price Lloyds had paid for it; their profit accruing from the loan of it for three years for the purpose of engraving. That part of the business was most admirably effected by Mr Sharp, the well-known line-engraver; and if report spoke truth and the Art Union of London paid £3,000 for the plate, Messrs. Lloyd must have received a satisfactory profit on this, as on many other occasions.'

CHAPTER FOUR

Derby Day (1858)

WHAT ABOUT TAXES AND DEATH DUTIES imposed upon us by modern govern-
ments and since Lloyd George's time? They are as nothing compared with the
hell-bent, insane exercises in financial self-destruction indulged in by many past
members of the aristocracy and gentry themselves. Early nineteenth-century
memoir-writers like Captain Gronow supply us with scores of instances, whilst
quite one of the classics in this field remains for all time 'Nimrod' Apperley's
Memoirs of John Mytton (1837), so aptly described by someone as 'an elegant
Palladian tomb'. A bloated, worn-out, young-old man of thirty-eight, he wound
up as a debtor in the King's Bench Prison, raving and incoherent, his death
formally ascribed to *delirium tremens*. 'Nimrod' puts it down with discreet and
breath-taking charity to a 'largeness of heart that ruined Mr Mytton, added to a
lofty pride which disdained the littleness of prudence'.

Much the same thing could no doubt be said of that contemporary of Frith's,
Henry Weysford Charles Rawdon Plantagenet, fourth Marquis of Hastings
(1842–1868), whose last words, spoken in a whisper and scarcely heard were:
'Hermit's Derby broke my heart. But I didn't show it, did I?' The Hastings story
has been brilliantly retold in *The Pocket Venus; A Victorian Scandal*, by Henry
Blyth (Weidenfeld & Nicolson, 1966). Reading it is like moving through Frith's
Derby Day in slow motion. So, inevitably, the painting was reproduced as the
book's dust-jacket.

Searching to assess the changing image of Hastings from boyhood to manhood
Mr Blyth detects his presence twice in the painting. So, is he then the young
swell seen in casual conversation with the gipsy girl in the right-hand corner of
the picture? He writes:

'The likeness, it is true, is remarkable; and the air of bored nonchalance exactly
reflects the mood of Henry on occasions such as this. The girl in the carriage
might also well be Florence Paget. But in fact, this could not be so. Harry, at the
time the picture was painted, would only have been fifteen, and so would Florence.

'If Frith *did* have Harry Hastings in mind when painting this picture . . . then an equally representative figure is of the young boy in the shiny topper who stands on the left of the canvas, his hands thrust deep into his pockets and a look of bewildered dejection on his face. Here might well be Harry as an Eton school-boy, who has swaggered across the Downs on the great day and paused, as an elegant swell, to listen to the blandishments of the thimbleman, and has then been tricked out of every penny in his possession.

'These two figures are typical of Harry at different periods of his life. Each repays careful study, for here is Harry in two stages of his career, against the background which was his world.'

The phenomenon of gambling as a species of mania, which assails us all in a variety of forms, but which can ultimately devour its extreme devotees, obviously intrigued and fascinated Frith since he returns to it over and over again as a picture-subject: in *The Salon d'Or* (1871); and, in his moral series, *The Road to Ruin* (1878) and *The Race for Wealth* (1880). It was this aspect of the subject which led to the production of *Derby Day*.

It was 1856 when Frith visited Epsom and witnessed the Derby for the first time: Blink Bonnie's year. But it could have been any horse's year as far as Frith was concerned; his interest in racing, as such, was nil. What *did* excite him was the opportunities such an occasion provided for an artist in search of a panoramic, 'slice of life' kind of subject, full of movement, colour and crowds. Frith says it was an incident at the old Hampton Court Race-Course some years earlier which implanted the germ of the idea in his mind which was later to blossom forth as *Derby Day*. In a booth at Hampton, which had been converted into a makeshift dining-hall, he saw a ruined punter seize a carving-knife and attempt to cut his own throat. Frith writes:

'The knife was fortunately as blunt as those instruments usually are in better regulated dining-rooms than the booth at Hampton, and though the man injured himself considerably, judging from the ghastly pallor of his face, and the awful evidence on his beringed hands, I did not believe his attempt was fatal, for he was instantly seized, and prevented from repeating the attack. I heard afterwards that he had been a heavy loser; and my informant said: "The fool has lost his money, but he won't lose his life; it wouldn't much matter if he did, for he ain't married, and he is an awful rip".'

When Frith visited Epsom, gambling-tents, thimble-riggers, and three-card-tricksters were thick upon the ground. The police had not yet cracked down on them. 'So convinced was I that I could find the pea under the thimble', Frith continues, 'that I was on the point of backing my guess, rather heavily, when I was stopped by Egg, whose interference was resented by a clerical-looking

personage, in language much opposed to what would have been anticipated from one of his cloth . . .'

The acrobats, the nigger minstrels, the gipsies; 'to say nothing of carriages filled with pretty women', together with the sporting element supplied Frith with a rich variety of material for the composition which was rapidly forming in his mind. He took mental notes of everything likely to be of use to him and made a rough drawing of the race-course whilst everything was fresh in his mind as soon as he got home.

'I cannot say I have ever found a difficulty in composing great numbers of figures into a more or less harmonious whole,' Frith muses, adding that he did not think that this was a gift or knack that could be acquired. 'Many artists with far greater powers than I possess fail utterly when they attempt compositions of more than three or four figures; while to me, the putting together of a small number of objects, either living or dead, presents difficulties occasionally almost insurmountable.'

However, granting one did possess this facility, he insists that too much time can scarcely be spent in making preliminary studies, 'always from nature, of separate figures and groups'. He arranged the general lines of his composition into what he termed 'a rough charcoal drawing', and after making innumerable studies from models of all the prominent figures, he placidly knocked off and went for his annual holiday – to Folkestone. He spent much of his time there preparing a small, careful oil sketch, with colour and effect finally planned: 'so that when I chose to begin the large picture I found the "course clear" before me'.

— *2* —

Since 20 January 1857 Frith had been working away feverishly on *Derby Day*, for which Jacob Bell sent him an astonishing bevy of pretty models to swell the numbers of those which Frith himself, no mean judge of a pretty face, secured for himself. Jacob Bell expressed a wish earlier that Frith should paint an important subject for him as soon as he hit on one agreeable to both their tastes. On seeing his sketch for *Derby Day* Bell decided that was *it*, and commissioned Frith to produce a painting, five or six feet long, for £1,500, copyright being reserved to the artist. A reasonable time was agreed upon to allow the picture to be engraved before it finally came to rest in Bell's private collection.

Frith writes: 'Many weeks were spent upon the large sketch, and a second one, now in the Bethnal Green Museum, was made, in which I tried a different arrangement of the principal group. It will be evident then, that, if the larger work failed, it would not be for lack of preparation. Before the picture was begun, the copyright for the engraving was purchased by Mr Ernest Gambart, for £1,500.

[61]

Gambart had taken a proprietorial interest in the work from the beginning. Between them, they engaged the services of the top photographer of the day, Robert Howlett, to record scenes at Epsom which might prove useful. They arranged to meet there, but failed to find him, in spite of Gambart's rushing around and frantically addressing every second person he met in his chaotic English: 'Have you, perchance, seen a man with his photograph machine?' No cause for alarm, though; Howlett was there, all right, quietly getting on with his job. He took a capital photograph of the grandstand which Frith found most useful as an *aide-mémoire* when he settled down to work on his ambitious canvas.

Frith found his model for the acrobat in a Drury Lane pantomime and got him to show up with his small son for modelling sessions at his studio after the usual bargaining over terms. This lad's notion of modelling was that it required him to be everlastingly turning somersaults. 'Amusing enough,' drily comments Frith, 'but it did not advance my picture; and it was with much difficulty that I stopped him going head over heels into casts and draperies to the confusion of both.' A pert, cockney lad, he found 'eddicated folk' comic. Thus, when one of Frith's children came into the studio with a message: 'Mama says, papa, will the models want luncheon?', the scornful imp mimicked her refined speech: 'Mamma-papa! Why don't you say father and mother, young 'un?', only to be smartly reprimanded by his dad, who, acrobat though he might be, disconcertingly found that there was more to modelling than he had bargained for. He found it a strain standing still or holding a pose any length of time and kept fainting; and, consequently, odd recuperative spells in Frith's garden, held things up. The artist realized that this could not go on, so, by increased payments he acquired their dresses, and these were donned instead by professional models, those to 'the manner born', so enabling him to get on.

As on many other occasions Frith got his wife and children to pose, commandeered the services of friends, kept the pretty girls Jacob Bell sent him busy, and provided welcome employment to the trail of professional models passed on to him with recommendations from fellow-artists. His friend, Tattersall, of racing fame, sent him a jockey answering to the name of 'Bundy': 'a delightful little fellow, who rode a wooden horse in my studio with all the ease of rein and whip that would have distinguished a winner of the Derby. He surprised me by his endurance of a painful attitude – that of raising himself in the stirrups and leaning forward, in the manner of his tribe. This he would do for an hour at a stretch.'

When Bundy sat for him for the last time Frith completed the two jockeys seen astride in the painting as well as one in the distance wearing a great-coat. They parted amiably ('I to work; he to the Marquis of Something at Chantilly') but not before Bundy told him: 'he would rather ride the wildest horse that ever lived than mount the wooden one any more!'

[62]

Portrait of a Girl Holding a Parasol.

Canvas laid on board. 9½ x 7½ ins. Courtesy of Sotheby-Belgravia, London.

This picture was originally a sketch for a detail of one of the girls seated in the carriages in *Derby Day*. See next illustration and Plate Five.

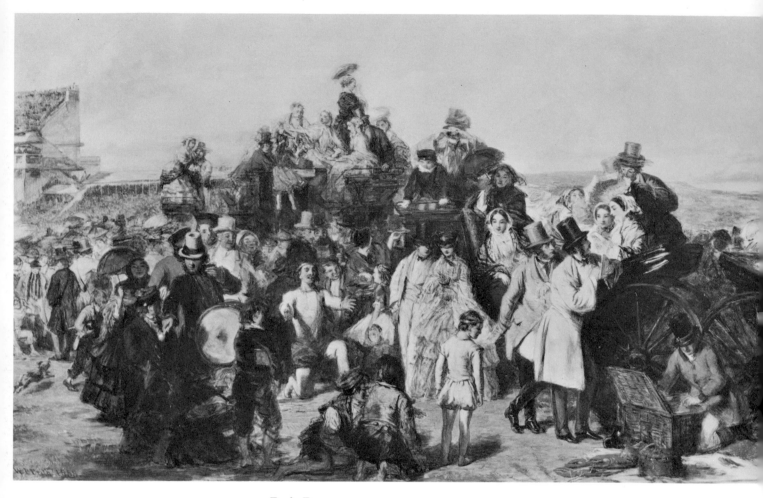

Derby Day.

1858. 11½ x 17½ ins. Courtesy of Thos. Agnew & Sons, London.

This is the third sketch, now hanging in the Bethnal Green Museum, London, for Frith's famous painting. See also Plate Five.

Frith acknowledges his debt to John Frederick Herring, Sen., (1795–1865): 'one of the best painters of the racehorse I have ever known, for the great assistance in the very small share the high-mettled racer had in my work', adding: 'I grieve to say that my little jockey friend was soon after killed by a fall from his horse in France.'

After fifteen months' incessant labour Frith completed *Derby Day* and sent it in for the Royal Academy exhibition of 1858. The sensation it created on Private View Day (2 May 1858) has become part of history and our national legend. In a letter to his sister, with whom he had kept up a regular correspondence since his mother's death, Frith describes the scene in the Academy's old rooms in Trafalgar Square when Queen Victoria and the Prince Consort paid their gracious visit to the exhibition on 9 May:

'When the Queen came into the large room, instead of, as she invariably did, looking at the pictures in their order according to the catalogue, she went at once to mine; and after a little while sent for me and complimented me in the highest and kindest manner. She said it "was a wonderful work" and much more that modesty prevents my repeating . . .

'It was on this occasion that the Prince Consort surprised me exceedingly by his intimate knowledge of what I may call "the conduct" of a picture. He told me why I had done certain things, and how, if a certain change had been made, my object would have been assisted. How the masses of light and shade might still be more evenly balanced, and how some parts of the picture might receive still more completion. I put many of the Prince's suggestions to the proof after the close of the Exhibition, and I improved my picture in every instance. There were several little Princes and Princesses in the Royal party . . .'

Gambart's half-share in the painting ensured its popularity from the outset, since he was such a master of the art of advance publicity. 'Like the roll of a side-drum preceding a fanfare', as Jeremy Maas puts it, he kept public curiosity about the picture on the boil for weeks before it went on exhibition. On 13 March *The Athenaeum* contained a piece by George Walter Thornbury: 'The spirited publisher who commissioned Mr Landseer to engrave Mlle Rosa Bonheur's *Horse Fair* has already entered into arrangements with Mr Blanchard . . . to engrave Mr Frith's *Epsom Race-Course* . . . We hope to see more English pictures engraved by Frenchmen, and more French pictures engraved by Englishmen.' That was merely the start of Gambart's press campaign.

— 3 —

Entry in Frith's Diary for 3 May 1858: 'Opening day of the Exhibition. Never

[65]

was such a crowd seen round a picture. The secretary obliged to get a policeman to keep people off. He is to be there from eight in the morning. Bell applies to the Council for a rail, which will not be granted.' Frith reproduces both his patron's letters to him and to the Council, and, if what Bell alleged was so the painting was clearly in danger. He writes of people, three to four deep in front of it; their faces 'within three or four inches of the canvas'. Next day, more excitedly, of 'people smelling the picture like bloodhounds'. Frith states that this appeal proved more successful and the iron rail *was* supplied. Diary entry for 8 May: 'Couldn't help going to see the rail, and there it is sure enough; and loads of people.'

But, Mr Maas wonders, was it Gambart rather than Jacob Bell who worked the oracle? He notes that although Frith reproduced Bell's letters in his *Autobiography* he omitted to quote from Gambart's letter to him, dated 6 May: 'which surely he must have brought to the notice of the President and Council since, more than Bell's letter, it hints at an ultimatum that cannot have failed to impress'. By courtesy of Frith's descendant, Diana, Lady Thomas, Mr Maas reproduces this letter in which Gambart writes:

'I was horrified by seeing the admiring public admitted to inspect your picture within 2 inches of the canvas, & when the policeman moves to get them back, his coat and buttons run great risk of Scratching the Surface; now, what with the dust & other improuvts [*sic*], unless the public is kept at a distance by a railing, my property in the Picture will be much jeopardised, & I beg to call your attention to my interest, begging that you will take such steps as will protect me.'

Whoever's intervention led to the rail being put in front of the painting it created a near-precedent, since, in the past ninety years of the Academy's existence, such precautions had been taken only once before: in 1822 when Sir David Wilkie's *The Chelsea Pensioners reading the Gazette of the Battle of Waterloo* went on view. Tongue in cheek, Frith told his sister, that, then, 'thirteen of the elderly Academicians took to their beds in fits of bile and envy; and though a few recovered by steadily refusing medicine, they never were in good health afterwards. This calamity was the cause of a resolution on the part of the Academicians in full conclave, that so invidious a distinction should never, under any circumstances, be made again; and when Messrs. Bell and Gambart, the proprietors of the *Derby Day* and the copyright thereof, took oath and said they verily believed their property to be in danger, the Secretary pointed to the towers of Westminster Abbey, just visible through the windows, under which repose the ashes of those distinguished men who fell victims to Wilkie, and then solemnly asked if a similar sacrifice was to be offered to Frith . . .'

Another Academician told Frith he would exhibit a work next year which would draw an even larger crowd than his *Derby Day*. Subject? 'I think I shall call it "Monday Morning at Newgate" – the hanging morning, you know. I shall

[66]

The Crossing Sweeper.

1863. 7½ x 6 ins. Courtesy of Christies, London.

For further details of this picture, many versions of which
are in existence, see Frith's *Autobiography,* Chapter 39.

have a man hanging, and the crowd about him. Great variety of character, you know. I wonder you never thought of it.' Frith leaves unrecorded his response to *that* one!

<center>— 4 —</center>

It will have been noted that Gambart paid as much for the reproduction rights as Jacob Bell had paid for the painting itself: £1,500. But, in the event, Gambart had bought not only the copyright of *Derby Day*, but, as Jeremy Maas puts it: 'in effect, the exhibition rights too. Now followed a complex series of negotiations over the immediate future of the picture; these were conducted through Edwin Field of Lincoln's Inn Fields, who acted as a friend to both Bell and Gambart.'

Jacob Bell was in poor health, and the last year of his life. His superb collection of contemporary paintings had been promised to the nation, but when on earth was *he* going to see *Derby Day*? On his own walls, that is. Frith learnt from Field that Gambart thought his painting 'so much finer and more finished than he had anticipated' that a longer time would be needed for its engraving, whilst Bell revealed in a letter to Field that Gambart was to have the painting for at least four years; that he even thought of lengthening this to seven years for a fee of £10 a month. What naturally worried the old pharmacist was that for long periods the picture could be anywhere: 'while I, the ground landlord, am not even permitted to know where it is – whether at the diggins [i.e. the gold-fields of Australia] or Timbuctoo, Lucknow, Delhi, or Algeria'.

It was all very complicated, but may be summarized thus: an agreement was reached between Frith, Bell and Gambart by 4 August 1858 which enabled Gambart to have *Derby Day* for engraving and exhibition for no less than four-and-a-half years (extended on 16 April 1859 for a further six months). This enabled the dealer to send the painting (or a version of it) in November 1858 to Leggatt, Hayward & Leggatt's establishment in the City – 79, Cornhill – before it was whisked off to Paris to be engraved by Auguste Blanchard . . . 'and finally on a triumphant tour throughout the world, causing a sensation and swelling Gambart's subscribers' list. Throughout the next few years Gambart continued to dazzle the British public with one or more versions of the picture' (Maas).

The green-eye'd instinct, never far below the surface in erring, sinful man can be relied upon to show itself early on in circumstances like these and help cut a successful man down to size; to preserve him from the dangers of getting big-headed. Frith's success with *Derby Day* and Gambart's adroit exploitation of it upset quite a few of Frith's colleagues and sparked off some ill-tempered snideries. That *rail* had been a very sore point. Millais wrote to Holman Hunt: 'I am sure

<center>[68]</center>

Frith is not getting a greater crowd round his work than we have experienced, & yet the wily dog has a *peeler* & a rail to protect his picture.' But the most notable overall criticism of Frith's crowd scenes was delivered later, and in finicky, dandaical, falsetto tones by Oscar Wilde: 'he has done so much to elevate painting to the dignity of photography'.

Frith's revenge came when he painted *The Private View of the Royal Academy, 1881*, in which his avowed purpose was not only to record for posterity the aesthetic craze in dress but 'to hit out at the folly of listening to self-appointed critics in matters of taste, whether in dress or art'. Frith continues: 'I therefore planned a group, consisting of a well-known apostle of the beautiful, with a herd of eager worshippers surrounding him. He is supposed to be explaining his theories to willing ears, taking some pictures on the Academy walls for his text. A group of well-known artists are watching the scene. On the left of the composition is a family of pure aesthetes absorbed in affected study of the pictures. Near them stands Anthony Trollope whose homely figure affords a striking contrast to the eccentric forms near him.'

The reference is clearly to Wilde, but Frith does not mention his gadfly tormentor by name: a form of name-dropping which skilful politicians (like Gladstone, who figures in this painting, and whom Frith found an admirable sitter) practise still with consummate effect! Like *Derby Day* it, too, had to be railed-in to protect it from possible damage by over-eager crowds: 'the sixth painted by me that has received this special compliment'. But more of that later.

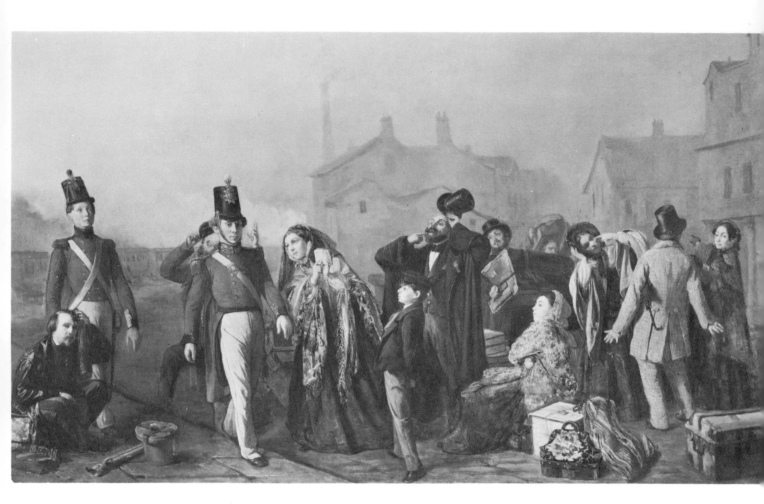

The New Recruit.

20 x 22½ ins. Courtesy of Christies, London.

CHAPTER FIVE

The Railway Station (1862)

IN THE 8 DECEMBER 1860 ISSUE OF THE *Illustrated London News* we read: 'Gossips talk mysteriously of a gigantic commission – amounting it is said to £10,000 sterling – given, or at least offered, to Mr Frith, R.A. It is too dark this dullest of Decembers, to see anything in the studios, so we were unable, even in our mind's eye, to discern the faintest outline of a sketch of Mr Frith's rumoured canvas. Who is the Lorenzo the Magnificent?'

The correspondent surfaced with the answer to his own question two issues later: 'Our information, which we have every reason to believe correct, points to M. Flatow, a gentleman well-known in connection with the "commercialities of art", as the Maccenas who is prepared to give the £10,000 in question. The picture contemplated by Mr Frith is said to be "Life at a Railway Station".'

Towards the close of his very long life Ernest Gambart got himself appointed Spanish consul at Nice and can be seen in the glory of his consular uniform, sporting a positive explosion of decorations, in the frontispiece to Mr Maas's book on him. He collected honours and decorations – they included the Légion d'honneur and the Order of Vasa of Sweden – with as much avidity as he did paintings and *objets d'art*. There was always a suggestion of the *grand seigneur* about Gambart; a hint of the diplomat of a somewhat foxy, Talleyrandish vintage. But the dealer who commissioned *The Railway Station* was not Gambart, this time, but his most formidable rival, Louis Victor Flatow: a very different kind of man.

Vulgar, loud-mouthed, and near-illiterate, he possessed, nevertheless, an uncanny flair for picking subjects that would 'go' when it came to pictures, linked to a superb understanding, instinctive rather than acquired, of the operations of the money-market. Many artists just could not stand him at any price. That was *their* loss. Those, who either were amused by his flamboyant, off-beat style, or were prepared to overlook it, seldom regretted letting him handle their work. They got better results, and quicker, when he took them up than they could ever hope to get handling their own work. For one thing he was invariably

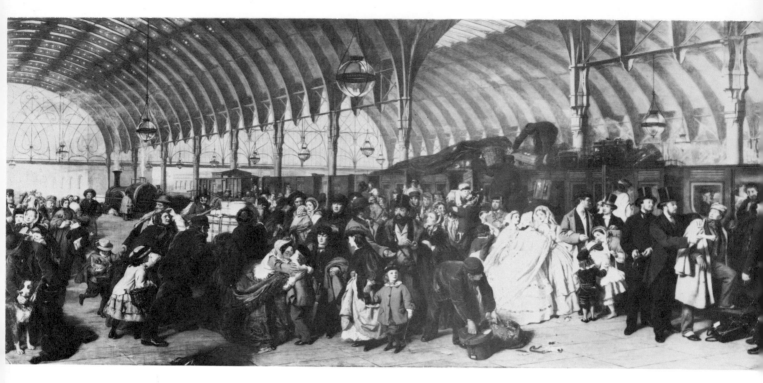

The Railway Station.

1862. 46 x 101 ins. Courtesy of Royal Holloway College, Surrey.

Following the sensational success of *Derby Day* (Plate Five) Frith decided to embark on an even larger epic of modern life, *The Railway Station,* which the public greeted with enormous enthusiasm. Frith includes portraits of himself and his family just to the left of centre.

accompanied by his wife, Anne, neatly and fashionably dressed, and with her cheque-book at the ready. Maybe, as Frith's daughter, 'Cissy', tells us her 'h's flew about like hail', and she had a habit of addressing her husband always as 'Chum', but no one complained about that cheque-book at the ready!

When Flatow lay dying of dropsy she nursed him patiently for ten months, and with some assistance from one of Frith's old models, Wall. He wheeled the stricken man around in an invalid chair and kept Frith posted about his condition. Flatow died at his residence, 49, Porchester Terrace, Bayswater, on 10 November 1866, aged only forty-seven. No more would artists and fellow-dealers hear his loud, confident voice shatter the air like a buzz-saw and with a boast: 'Lor' bless yer! There ain't a dealer in town as knows 'ow to manipulate a customer. You must walk round 'em, like a cooper walks round a tub.'

Maybe much of that gossip decanted into the 8 December 1860 issue of the *Illustrated London News* was exaggerated, but Frith was more than happy with Flatow's offer of £4,500 for the large picture: 'now being painted ... called *A Railway Station*, together with the original sketch and the copyright thereof', and described it as 'one of the most exorbitant on record'.

Frith spent the autumn of 1860 making studies for it, his preparations for it developing along much the same lines as those which proved so effective in the case of *Derby Day*, viz.: 'Many chalk drawings of separate figures and groups, many changes of composition and incident, before I could satisfy myself that I might commence the inevitable oil-sketch.' He felt, and few would disagree, that Paddington Station could scarcely be described as 'picturesque'; but we might not so readily share his view today that the ordinary traveller's costume in the eighteen-sixties offered little scope for a painter, since, it is precisely Frith's detailed rendering of contemporary costume which has given his paintings, a century later, an enhanced value, over and above their unquestioned merits as works of art: as 'documents' of immense appeal and inspiration to the social historian.

Most of 1861 was spent on *The Railway Station*. Frith's diary records details of incessant work, and the employment of a vast army of models. The models for his police officers were the genuine articles: two famous detectives of the day, Haydon and Brett. When Frith complimented them on being such excellent sitters they brushed his praises aside with the explanation that they were used to waiting for hours at a stretch sometimes, to pounce on a wanted thief or murderer.

One incident in his canvas shows a foreigner arguing excitedly with a cab-driver over his fare. The model here, Frith explains, was 'a mysterious individual who taught my daughters Italian; he hailed from Venice, at that time groaning under Austrian rule. He was a man of distinguished manners; and we were given to understand that he was a nobleman whose head was wanted in Venice to serve

a very different purpose from that [to] which I put it in this country. At first he refused to sit, as he dreaded recognition by some aristocratic friends who might come to England; and it was only on my promising that I would avoid making a likeness of him that I succeeded in overcoming his reluctance.'

Frith admits that he deceived the Italian count from the start: 'for, unless I caught the character of the face, I knew my model would be useless to me. The difficulty then was to prevent the portrait being seen till it was finished: this was accomplished on one pretence or other; but the inevitable moment came at last, and never can I forget the torrent of broken English that was poured upon me when my sitter first saw his face in the picture. "You say it shall not be like me, and it is as if I see me in a look-glass. You have betray me – it is perfide – my friends will recognise me. If I thought it was to be so I would not have do it."' Frith shamefacedly concedes in his *Autobiography* that the Count was right; his own conduct, 'indefensible'.

However, there it was. The painting, which he began on 28 August 1860 was ready in March 1862. Frith sold the exhibition rights to Flatow for another £750: 'thus acting in a manner believed to be without precedent in a Royal Academician' (J. Maas). Frith was criticized in some quarters, certainly, for not showing his painting at the Royal Academy first. In April it went on view in a small gallery at 7, Haymarket, to mixed, if on the whole, friendly notices. Frith comments: 'The critics contradicted one another, as usual, without doing good or harm to me or the picture.'

He claimed that 21,050 people paid to see his picture within seven weeks and that subscriptions for the engraving from it proved 'equally surprising and satisfactory'. The exhibition closed on 30 September. According to the *Illustrated London News* (20 September 1862) about 83,000 people had seen the painting, and 'the subscription list for the engraving is also very large'.

Flatow bustled around during the exhibition, 'coaxing, wheedling, and almost bullying his unhappy visitors' in such a way that Frith suspected many people subscribed for the engravings simply to get rid of him! Indeed, he closes his chapter on the painting in his *Autobiography* with an amusing illustration of Flatow in action:

'He used to boast that he could induce the most unpromising visitor to subscribe; and on one occasion, as I was talking to him in the outer room, a fashionable, languid-looking gentleman, having seen the picture, was on the point of taking his umbrella and his departure. I whispered to Flatow: "I will bet you half-a-crown you don't get that man to subscribe." "Done with you!" said Flatow, and immediately went to the young visitor and, touching his hat, said: "I beg pardon, sir – have you seen a specimen of the manner in which this wonderful picture is about to be engraved?" "N – no," drawled the dandy. The umbrella

was put back, and the visitor returned to the picture in the custody of Flatow. In a very few moments he came back in the act of buttoning his gloves; betrayer and victim exchanged farewell salutes, and the former rejoining me, said: "I will trouble you for two-and-sixpence." '

However, the Flatow story I like best is the one in which he proved less successful; when he, in fact, met his 'Waterloo' – and, at the hands of the Paddington 'hengine-driver'. Not only had Flatow been wildly enthusiastic about the idea of a railway picture from the moment he saw Frith's preliminary sketch for it (and when the artist himself had serious misgivings about it as a subject), but he was eager, too, to figure in the picture himself: 'After all, it's my money will make the pictur' go.' So, schoolboy-like he set his heart on modelling as the 'hengine-driver'. But the real engine-driver would stand none of that nonsense; it was his engine: 'me and my hengine goes together'. So, Flatow resigned himself to figuring simply as one of a crowd of passengers, albeit one privileged to talk to the driver, who looks down upon him from the vantage-point of his cabin with all the condescension and complacency of the thoroughgoing professional. 'Cissy' Frith assures us that her father depicted Flatow accurately as 'a good, fat, vulgar little Jew'.

Flatow had the last laugh of everybody, though, since he left a fortune and cleared £30,000 in exhibition fees and in subscriptions for *The Railway Station* alone. A pity the art world had to lose 'Chum' only a few years after he had commissioned this wildly successful painting from Frith, and miss the fun of his non-stop patter and Wellerisms, as quotable in his own day as the aphorisms of Sam Goldwyn are in ours.

The Flower Girl.

1865. 15½ x 11½ ins. Courtesy of Thos. Agnew & Sons, London.

Frith painted another picture of the same title but of a different size (12½ x 9½ ins.) in 1892 which was subsequently sold to Frank Failey on 10 August, 1893.

Frith's Relations with the Dealers

THE PUBLIC RELATIONS SIDE of a film studio is described, meaningfully, as the Exploitation Department; their job is to *sell* films to distributors and the public. Most of us are familiar, from magazine and newspaper features, with the lavish and ingenious way they often do it. But the manner in which nineteenth-century dealers and manipulators of engraving copyrights operated is no less fascinating an area of study; and, indeed, it awaits detailed exploration.

As Ronald Pickvance observes in his introduction to the catalogue of the Scottish Arts Council exhibition, *A Man of Influence: Alex Reid, 1854–1928*, the power and influence of the dealer has grown so much from 1850 onwards that his actions and decisions have affected the development of painting no less than the course of collecting: 'For the historian, the dealer's activities must have as much importance as the patron's whims and demands had in fifteenth-century Italy or eighteenth-century England. And the time is surely ripe when some study should be given to the dealer's archives which could shed light on obscure corners of an artist's career, or elucidate the growth of a collector's taste.'

It was precisely with this thought in mind that Mr Jeremy Maas, a leading London dealer himself, set about his study of Ernest Gambart (1814–1902), whose activities were, he felt, 'very important – perhaps crucial – to our under-standing of the Victorian art world'. Frith, it may be recalled, did not immediately fall in line with his father's plans to have him trained as an artist. He felt that life as an auctioneer might be more profitable and attractive. However, it was agreed that father and son should set out from the Dragon Inn, at Harrogate, for London, Frith's father declaring: 'I will take your drawings and show them to Sir Launcelot Shadwell's friend, the R.A. If he says you ought to be an artist, will you go to this Mr What's-his-name in Bloomsbury and learn the business? If he thinks nothing of your drawings, I will apprentice you to Oxenham's in Oxford Street, and you can learn auctioneering. Now, what do you say?'

This incident, recorded in Frith's *Autobiography*, elicited a characteristic quip

from Whistler when he read the passage after the book's publication: 'an auctioneer? An artist? Frith must have tossed up for it!' An observation comparable, say, with Harpo Marx's celebrated description of his friend, Alexander Woollcott: 'Just a great big dreamer, with a nice sense of double-entry book-keeping.'

If Gambart is the nineteenth-century dealer, *par excellence*, Frith personifies the artist's response to such dealers, who, providentially surfaced to replace the old-style aristocratic patrons: a near-vanished breed by the 1840s, who had, for the most part, abandoned supporting living artists and settled simply for acting as curators of the Gainsborough and Reynolds portraits in their own mansions, which their grandfathers had commissioned. The new patrons sprang from an entirely fresh, emergent stratum of society: the tycoons thrown up by the Industrial Revolution: the iron masters, cotton kings, and pharmacists like Jacob Bell, who commissioned *Derby Day*; the meritorious Flatow, who nursed the idea of a 'pictur' about a railway station' into life; the ubiquitous Gambart.

Considerable space was devoted in Frith's obituary notice in *The Times* of 3 November 1909 to an exploration of this subject of the artist's relations with the dealers. After a passing reference to the old days when it had been customary for collectors to buy direct from the artist: 'a method which sounds simple and unobjectionable', *The Times'* memorialist continued: 'But every memoir of every artist of those days shows that the plan worked badly; that personal idiosyncracies came to play too large a part; that buyers were exacting, patronising, changeable; that after a time the artist would feel humiliated, would lose his temper, and, as a consequence, his client.

'Frith frankly admits that when he had once tried the dealers he, for these reasons, refused as a rule to sell to anyone else, preferring to hand his productions over on pure business lines.'

Agreed, as we have seen in the amusing instance Frith supplies of Flatow's 'death-of-a-salesman' technique during the exhibition of *The Railway Station* their efforts were often embarrassingly vulgar, yet, as *The Times* reminds us, Frith made twice as much out of the business than he would have done if he had kept the management in his own hands. Moreover, such dealers helped create a vast market, 'by means of which the English artists and engravers, as well as the dealers, enjoyed thirty years of such prosperity as none of them had ever known before. Frith, in conjunction with Gambart, Flatow, and some others, really woke up the great British public to the desirability of possessing pictures, or at least engravings.'

I hesitated as I decanted the quotation into my text whether or not to italicize that phrase, *or at least engravings*, adding (my italics); but, certainly, one beneficial effect of the mid-Victorian art boom was that middle-class householders, who would never have dreamt of commissioning work from artists directly or purchas-

Portrait of Isabel Lucinda Smith.

$36\frac{1}{2}$ x 28 ins. Courtesy of Thos. Agnew & Sons, London.

ing paintings before, began doing so, or at least acquired the habit of subscribing for engravings. Several generations of children have since grown up surrounded by housefuls of them and so acquired an early taste for art long before they ever set foot in a gallery.

No one who frequents the galleries at Sotheby-Belgravia, 19, Motcomb Street, London, S.W.1, today, can fail to agree how true a prophet the correspondent in the August 1849 issue of *Art-Journal* proved when he remarked on the phenomenon of this new middle-class patronage: 'many of these [dealers] are gathering round them galleries of Art which, at some future day will rank as high as any of past times, and in monetary value will be as marketable'.

True, some of these new patrons lacked the dubious advantages of the formal education inflicted on the aristocratic patrons of former times, and a facility in turning out tributes to Nelson and Wellington in Greek hexameters or Latin verses. They acquired whatever education they did possess in an untidy, patchwork, 'Samuel Smiles' kind of way. But some of them were shrewd enough to grasp the fact that many of these highly-educated gentry on their Grand Tours had bought 'Old Masters' later discovered to be of suspicious provenance; oven-baked fakes, possibly, or inferior studio-copies by pupils. They were determined themselves not to be caught *that* way, and so patronized living artists; fellows they could keep an eye on, just like their own factory-workers. They visited their studios and saw them at work, carrying out their orders; producing their pictures. They knew what *they* liked, and were happy to pay for it. Moreover, they *knew* who painted their pictures. They could produce receipts. And, if they did not run to paintings, there were always the engravings.

Frith, who made himself so very much at home in this world, has suffered much off-hand criticism for the alleged 'complacency' said to be evident in certain passages of his books, especially those in which he supplies details of his success: his fees, his social triumphs, his distinguished sitters. But, such strictures require serious qualification. One golden rule for a biographer is: he should remember at all times that his 'subject' is the star of the show; he, merely the *compère*. In presenting his 'subject', he should, as far as possible, let him speak for himself: 'he shall his own biographer be'.

As I have read and re-read Frith's works and correspondence pretty thoroughly whilst at work on this book, and in an attempt to get inside the artist's mind, I have been struck not so much by his much-publicized 'complacency' as by Frith's quiet acceptance that there is an awful lot of luck or chance in life; a preoccupation with the baffling mystery of why it is some artists succeed, whilst others, equally good or even better, do not. No 'complacency' informs this reflection buried away in the pages of Frith's *Autobiography*:

'Notoriety is not fame; and when it can be remembered that an obscure artist,

called Glover, found ready sale for his landscapes, whilst Gainsborough's were neglected; that Romney fell out of fashion while in the plenitude of his power; that Constable only sold his works with difficulty, and at very small prices; and that Turner had a whole gallery full of pictures that he could not sell – it is wrong to rely on popularity as a proof of merit, or the neglect engendered by fashion, and fed by ignorance (which is the fate of all painters, sooner or later), as evidence of failing powers.'

Born in the same year as Queen Victoria, Frith lasted out until his ninety-first year (1909) and was active during most of them. Personally, I detect a note of humility rather than 'complacency' in this quiet passage of his: 'I find by my diary that the "Coming of Age" was begun on one of the last days of September 1848, and finished in April 1849; and if some of my young student friends could see my diaries for the last five-and-forty years, they would see a record of incessant work – no day, literally, without a line – that I do believe would surprise them. My work has never been interrupted, I am thankful to say, by illness, and I never allowed it to be interrupted by anything else.'

Now, for a quotation to end this chapter on the great Victorian dealers and Frith's relations with them: Frith's remembrance of a Bond Street without a single gallery in it!

'If the "Bond Street lounger" of fifty years ago could revisit that street, he would scarcely recognize the scene of his youth. I can well remember it, and I think I can safely assert that there was not a picture-shop in the whole length of it. Now they are to be counted by scores, to say nothing of the galleries that abound . . .'

Quite so!

Roger de Coverley and the Perverse Widow.

1869. Canvas. 16 x 20 ins. Courtesy of The Leger Galleries, London.

Exhibited at the R.A. in 1870 this painting illustrates the following passage from Addison in *The Spectator:* 'After she had done speaking to me, she put her hand to her bosom and adjusted her tucket. Then she cast her eyes a little down, upon my beholding her too earnestly. Her confidant sat by her, and upon my being in the last confusion and silence, this malicious aid of hers, turning to her, says: "I am very glad to observe Sir Roger pauses on this subject, and seems resolved to deliver all his sentiments upon the matter when he pleases to speak."'

CHAPTER SEVEN

The Marriage of the Prince of Wales (1865)

ON 25 JANUARY 1858 THE ELDEST of Queen Victoria's nine children, the Princess Royal, was married in the Chapel Royal, St James's, London, to Prince Frederick William of Prussia. As the Princess Royal knelt beside her groom, an artist was busy making sketches of the scene. It was this exact moment that was to be fixed on canvas by John Phillip, A.R.A. ('Spanish' Phillip). Some of his paintings which the Queen had bought obviously impressed and convinced her that he could both handle crowd scenes effectively and capture likenesses.

Frith had been approached earlier. In July 1857 she commanded the Keeper of the Privy Purse, Sir Charles Phipps, who was also the Prince Consort's private secretary, to ascertain if Mr Frith would be agreeable to paint a group from the ceremony of the marriage: could he keep himself 'disengaged for the purpose'; and, further, could he give some idea of 'the cost of such a picture'?

Frith writes: 'The "command" surprised me in the act of finishing *Derby Day*, and I was permitted to urge the claims of that work, and its owners, as an excuse for declining a task afterwards so ably performed by my friend Phillip, but when I was again summoned to a more formidable effort in the shape of the marriage of the Prince of Wales, I felt I must obey; though I was aware of the fearful difficulties that such a subject presented – scarcely exaggerated by what Landseer said to me when he heard of my temerity: "So you are going to do the marriage picture? Well! for all the money in this world, and all in the next, I wouldn't undertake such a thing." '

It was a ticklish situation. Frith had respectfully declined one royal 'command' and doubtless felt that *this* time, he must obey. Maybe, too, the thought that Sir George Hayter and Landseer, who painted for royalty, both received knighthoods, and had every prospect of further royal commissions, led him to decide to accept the commission. Nevertheless, it did present an awkward problem, since, in March 1862 he had completed *The Railway Station* for Flatow, and Gambart, eager no doubt to upstage his rival, had secured Frith's agreement to a fresh

commission of a most ambitious kind and on the most generous terms. He was to paint three pictures for him, in which the figures 'shall not be of a less size than the figures in the picture called *The Railway Station*'.

Frith was delighted with this commission and goes out of his way in his reminiscences to stress the fact that the fee had been offered by Gambart, not demanded by himself. The three pictures of London street scenes were to be called *Morning*; *Noon*; and *Night*. Frith writes: 'The first represented the early dawn of a summer's morning, with a variety of incidents possible to the occasion: homeless wanderers, asleep and sleepless; burglars stopped by police red-handed, flower-girls returning from Covent Garden with their early purchases, belated young gentlemen whose condition sufficiently proved that the evening's amusement would not bear the morning's reflection; with other episodes more or less characteristic.

'In *Noon*, the *mise-en-scène* was Regent Street in full tide of active life. Ladies in carriages, costermongers in donkey-carts, dog-sellers, a blind beggar conducted across the street by his daughter and his dog, foreigners studying a map of bewildering London, etc. etc. The night scene was intended for the Haymarket by moonlight, the main incident being the exit of the audience from the theatre; a party is about to enter a carriage, and a gentleman is placing a young lady's cloak closely about her shoulders, in tender lover-like fashion. This is being observed by an over-dressed and be-rouged woman, whose general aspect plainly proclaims her unhappy position; and by the expression of her faded though still handsome face, she feels a bitter pang at having lost for ever all claim to manly care or pure affection.'

By the terms of the agreement entered into between Gambart and Frith on 29 August 1862 Frith 'agrees to sell the copyright therein, together with the original sketches thereof, and all further sketches or drawings made or to be made in furtherance of the said pictures, for the sum of ten thousand pounds, to be paid by instalments as follows, namely: Five hundred pounds on the signing of this agreement; five hundred pounds at the expiration of three calendar months from the commencement of the said pictures, and a like sum of five hundred pounds at the expiration of every succeeding three calendar months until the whole of the said sum of ten thousand pounds shall be paid . . .'

Gambart, and indeed, and understandably, most dealers were normally tough on artists who tried to wriggle out of agreements, but, as Mr Maas hints, Gambart would have been astute enough to have sensed a means of turning the situation to his advantage: 'Only a few weeks before, the firm of E. Gambart & Co. had announced the publication of the engraving by Blanchard of "The Marriage of H.R.H. The Princess Royal", after John Phillip.' Frith's diary entry for 18 January 1863 briefly records the outcome: 'Gambart called, and agreed to the

Frith in His Studio.

24 x 18¼ ins. Courtesy of the National Portrait Gallery, London.

A self-portrait of Frith talking to a model in his studio at 10, Pembridge Villas, Bayswater. The setting reminds one of his conversations with the royal bridesmaid's mother during work on *The Marriage of the Prince of Wales:* 'What a queer place! Why do you shut up part of your window?'

postponement of the street pictures in consequence of the Queen's wish that I should paint the marriage of the Prince of Wales.'

Although the *Marriage of the Prince of Wales* is a tremendously successful and ambitious work, and apart altogether from its artistic merit, a historical 'document' of lasting importance, it is a pity that the 'Streets of London' series at varying times of the day was, in the event never completed albeit we have his three completed sketches, one for each picture, which do supply us with some idea of what we have lost.

True, Frith devotes a chapter in his reminiscences to *The Marriage of the Prince of Wales*, but since these came out in the Queen's lifetime he had to be somewhat circumspect and his own account needs to be supplemented by the information supplied later by Frith's daughter 'Cissy' (Mrs J. E. Panton) in her volumes: *Leaves From a Life* (1909); and, *More Leaves From a Life* (1911). She never could understand why in her father's time royalty always paid less for their pictures than anyone else, and felt sure that her father lost hundreds of pounds over his work on the *Marriage*. She writes: '. . . and what it cost him in wear and tear of nerves, time and temper, no one will ever know. Of course he gave a guarded description of his doings with the Royalties in his own book of *Reminiscences*. I only wish he had told them at length, but in those days Queen Victoria was still alive, and he had actually to submit his proof sheets to her before the book was published!'

We have already mentioned our indebtedness to Mr Jeremy Maas's book on Gambart and must here do so again in respect of his later contribution to Frith studies, *The Prince of Wales's Wedding (1865): The Story of a Picture* (1977). Since its appearance coincided with the recent Jubilee celebrations of the present Queen, and might well strike the casual bookshop browser as simply an agreeable 'coffee-table' style of thing, we feel it worth stating here that it is, on the contrary, a study in great depth, based on papers in the Royal Archives at Windsor and on documents which have remained in the artist's family, and reveals in agonizing detail what precisely Frith had let himself in for when he put to one side the series of pictures for which Gambart was prepared to pay £10,000 for the privilege of painting the *Marriage* for an agreed £3,000.

— *2* —

'Another year begun in my sorrow and loneliness', Queen Victoria wrote in her Journal for 1862. 'May God help me on! It no longer means anything to me, no fresh chapter of life – nothing!' But, as we know, the Widow of Windsor continued to reign for another forty years. Her immediate resolve as regards the

heir to the throne was to carry out two plans Prince Albert had in hand before his death in 1861: a tour of the Holy Land for his son, and the formal announcement of the engagement of the Prince of Wales to the Princess Alexandra of Denmark. The marriage was a grand affair and the Queen let it be known that she wished Frith to record it worthily.

We do not feel it is necessary, since Mr Maas has so ably anticipated us here, to give a round-by-round, blow-for-blow description of all the tiresome difficulties which beset Frith as he struggled with his Herculean task. Not only was he hampered by the archaic court procedure which made it virtually impossible for the artist to communicate direct with his royal patron, but by the ill-bred, boorish and downright obstructive behaviour of so many nineteenth-century 'royals' and aristocrats.

When negotiations opened, Frith had to communicate with the Queen through Sir Charles Eastlake, P.R.A., who in turn had to write to Sir Charles Phipps, the Keeper of the Privy Purse, who, in his turn had to relay everything to the Queen's Resident Bedchamber Woman, Lady Augusta Bruce (later to marry Dean Stanley of Westminster Abbey). It was a pretty wearing business for all concerned.

We have noted how much Frith appreciated the Prince Consort's well-informed comments and suggestions about *Derby Day* and benefited from them, and he has gone on record with the statement that 'it was a matter of regret to me that I was deprived, by the lamented death of the Prince Consort, of a critic whose remarks would have been of great use to me' (i.e. when working on *The Marriage*). Fortunately, no one pays much attention today to the lubrications of that faded belles-lettrist, Lytton Strachey. We have since acquired a sounder and better-informed view of Prince Albert's incontestably fine qualities. Works like Winslow Ames' *Prince Albert and Victorian Taste* (1966), for example, have helped us all to appreciate how well he used his position to promote the fine arts. But one aspect which we hope Robert Rhodes James will bring out in the forthcoming study of the Prince on which he is engaged, and which will be based on much unpublished material in the Windsor archives, is the constant pin-prick and suffering he had perforce to endure from the ill-bred and boorish manners and snideries of so many of our so-called aristocracy, to whom he remained till his death, 'the foreigner'.

It was an unlovely, yet so prominent a feature of social life that it has surprised me it is not stressed more often in discussions and in literature on nineteenth-century life. The paranoiac obsession of so many boneheads with their tom-fool titles and the imagined significance of their 'social rank' vitiated all attempts at easy and civilized communication with them. To go through Mr Maas's book in slow motion, as we have done several times, is to be confirmed in our view that however agreeable the Stately Home countesses and dukes may be today as they

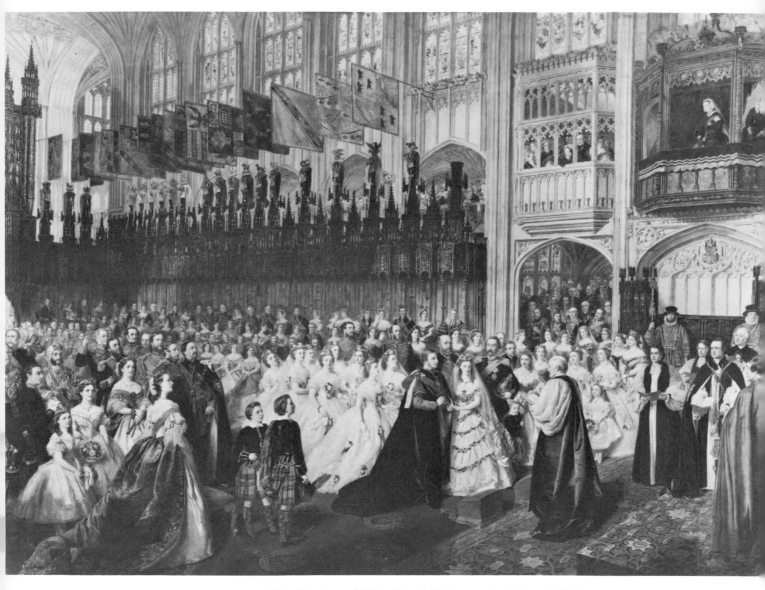

*The Marriage of Their Royal Highnesses the Prince of Wales
and the Princess Alexandra of Denmark in St. Georges Chapel,
Windsor, March 10th 1863.*

1865. Canvas. 59 x 83 ins. Courtesy of The Walker Art
Gallery, Liverpool.

The original of this painting, more commonly referred to
as *The Marriage of the Prince of Wales,* now hangs in Windsor
Castle. It took two years of exasperating work to complete
and marks for some the turning point in Frith's career as a
creative artist, lacking as it does the 'zest' of *Ramsgate
Sands* and *Derby Day,* though nonetheless exciting intense
public acclaim on its first showing at the R.A. For a
detailed study of this painting see J. Maas, *The Prince of
Wales's Wedding (1865): The Story of a Picture* (1977).

hand us our guidebooks and change, or direct us to the strawberry-and-cream tea-rooms, the odds on that their grandparents were right 'swinos' is pretty high. Frith was a problem, naturally. With their limited range of interests they probably did not meet many authors or painters and could not quite 'place' them. Frith suffered a great deal from their tiresome and inconsiderate antics; moreover, his own quiet, unimpressive appearance and demeanour did not help him much.

The difficulties Frith had to contend with in the initial phase of negotiations over the painting *before* the wedding, and as correspondence got circulated around from one official to another was as nothing compared with those which crowded in on him *after* the wedding, and as he pursued by correspondence all those of whom he required sittings for the painting of the royal wedding. As can be seen from the painting itself the prominence of the bevy of bridesmaids in it clearly required that they should show up for sittings, and in all the finery worn at the wedding itself, as soon as convenient. But let Frith tell his own story:

'Letters had to be written by the score; answers came sometimes, and sometimes silence was the answer. In my applications for sittings and dresses, I had forgotten to say that the picture was painted for, and by command of, the Queen; when that announcement was added, consent in most cases came readily enough. All the bridesmaids but one promised to give me every advantage. From one lady I received no reply; but in place of it a visit from her mother . . .'

Like Lady Catherine de Bourgh, this matriarch laboured under the impression that an insolent tone and manner was required of her on this occasion to impress upon this painter fellow that the time of both herself and her daughter was of immense value, and that both were ladies. Frith found her in a bewildered condition in his drawing-room at Bayswater one day, looking with a puzzled expression at various ornaments in the room. The following conversation ensued:

'I think I have made a mistake; it is the artist Frith I wished to see.'

'Yes; I am that individual.'

'Oh, really! and this is your – this is where you live?'

'Yes; this is where I live' (and not, thought Frith, 'in the garret where you had evidently been taught that most artists reside, and as I have a coal-cellar I am not forced to keep my fuel in a corner of the garret, and I am not always dining on the traditional red herring').

'Oh, then I have called in reply to a letter from you, asking my daughter, Lady ——, who was one of the Princess's bridesmaids to sit for a picture, to tell you it is impossible for her to sit; and as to her dress, which you ask for, she cannot spare it.'

'Indeed! I am sorry to hear this; however I will represent what you tell me to the Queen, and I dare say I shall be allowed to substitute one of my models, who must play the part of bridesmaid instead of Lady ——.'

[89]

Her expression at this point told an amused Frith as plainly as any words her thoughts: 'what does this man mean with his Queen, and his model, and his independent, impertinent manner'. After a spiky pause she asked: 'Why are you painting this picture? What is it for? Cannot I see it?' Pointing to his painting-room, Frith replied: 'If you will walk this way I shall be happy to show it to you.'

'What a queer place! Why do you shut up part of your window? Oh, that is the picture! Well, what is it done for?'

'It is done for the Queen.'

'Done for the Queen! Who presents it to the Queen?'

'Nobody – the Queen presents it to herself; at any rate, she pays for it.'

'Really!'

'Yes; really.'

Then, in the most respectful manner he could muster in talking to this weary-dreary snob, Frith added: 'I am well aware how much young ladies are engaged, and how disagreeable it must be for them to waste time in sitting to artists when it can be so much more usefully occupied; so if you will allow me, I will tell her Majesty, through Lady Augusta Bruce, that your daughter is unable . . .'

Another pause before the lady recovered herself to protest in a petulant tone: 'Really, I think the Queen when she asks ladies to be bridesmaids, should tell them that they may be called upon to go through the sort of penance you propose to inflict upon my daughter.'

'I thought I had made it clear that I should prefer to use one of my models than that your daughter should be annoyed; and if you find she cannot consent, I will write to Lady Augusta Bruce . . .'

'Well, good-morning. I will let you know; I will see what my daughter says.'

The young lady came and proved one of the most agreeable of Frith's sitters.

Several of the foreign 'royals' at the wedding proved difficult but the worst-mannered was Prince William of Denmark (soon to become George I of Greece). An appointment was made for a noonday session with him in the conservatory at Buckingham Palace, when Frith with a photographer in attendance, would photograph him in uniform. When the Prince showed up, five hours late, he was in everyday dress. When discreetly reminded about the uniform, he snapped: 'I cannot dress myself up to please you.' However, a photograph was taken. He demanded to see it. Reluctantly, the photographer showed him the negative, which, knowing little about photography obviously, he did not like. It was patiently explained to him that normally more than one pose was desirable. Would he kindly pose again? No! He stalked right out of the conservatory, having wasted the best part of the day for Frith and the photographer.

A close runner-up was Prince Louis of Hesse, husband of the Queen's daughter, Princess Alice. An irascible, impatient man, he turned up at Frith's studio with his

gentleman-in-waiting, Captain Westerweller, who stood rigidly to attention whilst his master sat. Frith considerately suggested he might care for a chair? The Prince took one of the endless cigars he smoked during the sittings out of his mouth, and barked: 'He vill schtaand!'

An amusing tailpiece here: after the Prince's visits Mrs Frith had a habit of bustling around the house with a shovel, burning incense bought from a local repository near a Catholic chapel in her vain attempts to get rid of the fog of cigar-smoke left behind. Dr Charles Longley, the Archbishop of Canterbury showed up for one of his sittings just after Mrs Frith had been busy on one of her incense-burning forays. With a twinkle in his eye, he asked Frith: 'Have you had Manning here?' It was closer to the mark than he knew since Cardinal Manning visited Frith a few times and 'Cissy' suspected that he had it in mind to make a convert out of the freethinking artist. Naturally, the bishops proved much more agreeable sitters than some of his others, asked sensible questions about his work, and often told him amusing stories.

Some idea of Frith's problems can be gleaned from the fact that he had to wait two months before the bridegroom appeared for his first sitting! It was important, too, that the bride herself should look in sometime – but, one problem at a time. At last, on 11 May 1863, Mr Herbert Fisher, Private Secretary to the Prince of Wales, 'presented his compliments to Mr Frith and is desired to inform him that the Prince of Wales will sit to him at his studio tomorrow (Tuesday) at 3.30 for an hour'. On the day itself Fisher wrote again: the Prince had been 'prevented by unforeseen interruptions from keeping his appointment'. Next day a fresh appointment was fixed for Saturday at 11 a.m. for an hour; and, this time, he showed up!

Princess Alexandra's first session was fixed for 11 a.m. Friday 29 May. However, Frith was warned in advance that the Princess was 'much occupied now and soon gets tired when sitting for her picture'. She would prefer two short sittings to one long one. 'That first sitting, can I ever forget?' Frith sighed. To help the Princess brave the ordeal the Duchess of Cambridge held her hand throughout the sitting. Even so, Frith was flummoxed by the way she seemed incapable of keeping her face in one position for a few minutes even: 'so necessary to enable an artist to catch a resemblance of it'. After two or three more abortive sittings Frith opened his heart to the Prince. His simple advice? 'You should scold her!'

It just so happened that John Gibson, the sculptor, fresh back from Rome, had been commandeered to sculpt the Princess's bust at Marlborough House. It was not a good likeness, and Frith told Gibson so. He agreed. 'Well, you see, the Princess is a delightful lady, but she can't sit a bit.' A few moments later the royal couple drifted into the room. 'How do you find the Princess, Mr Gibson?' asked the Prince. This was a real poser! Frith knew that Gibson could scarcely

eat the words he had just uttered, and, for an awkward moment, all three men exchanged looks. The Prince smiled, 'There, you see,' he said, turning to his wife; 'you neither sit properly to Mr Gibson nor to Mr Frith.'

'I do – I do', cried the Princess; 'you are two bad men!' But, after that, she was as good as gold; as good as her own Prince, who sat steadily enough for Frith.

With the likenesses of the bridal couple firmly limned-in upon his canvas Frith found it a shade easier than before to handle the 'victims' he still required as sitters; but it continued to be fearfully hard work at times, chasing them all up and inveigling them into his studio. He worked outwards from this stage from the bridal pair, tipping in a figure here, a figure there, as the sittings dictated or made possible. However, five months after the wedding ceremony, he was still saddled with the task of rounding up over a hundred more sitters whose presence in St George's Chapel made their appearance in his mammoth canvas desirable.

In September Frith had a brainwave. He heard, no doubt through Lady Augusta Bruce, that in the late autumn the Queen would be holding 'courts' at Windsor and that large contingents of European 'royals' and their suites would be at Windsor as guests. So, on 2 November 1863, Frith duly arrived at the Castle with his ten-foot canvas and set up his easel in the Rubens Room, where, in a sense, Frith himself may be said to have 'held court' for nearly seven weeks.

On 8 November 1863 Frith wrote to his sister: 'Here we are cheek by jowl (rather a vulgar expression that) with royalty, and if painting were not so difficult, it would be very delightful indeed; for nothing can exceed the kindness of everybody with whom I come into contact . . . The Queen sits tomorrow from one till two. I have tried hard to get her to sit for an hour and a half; but she says she cannot spare the time *at once*, and would rather sit any number of times an hour at a time . . .

'As to the Princesses, they would be considered most charming girls anywhere; none of their photographs do them justice. The difficulty is to keep in mind in whose presence you are – they laugh and talk so familiarly, and still sit well. Princess Beatrice, too, is a most sweet little creature, and as I took Princess Helena's advice, and *overawed* her a little, she sat right well; but she began to take liberties at last, and I am afraid next time I shall be troubled to keep her quiet. As to Prince William of Prussia, of all the little Turks he is one of the worst; and how I am to get a likeness of him I don't know. I let him paint a little on the picture, which delighted him. At the same time I was painting Princess Beatrice's dress from the lay figure, when the door of the Rubens Room (where I am at work) was thrown open, and a man shouted, as if he was proposing a toast at a public dinner, "The Crown Prince of Prussia and the Royal Family".

'And in marched the Crown Prince (who had arrived at the Castle unexpectedly) with his three children, their nurses, and all the English Princesses and their

Blessing the Children at Boulogne.

1874. $27\frac{1}{2}$ x 41 ins. Courtesy of Christies, London.

An episode in the great annual procession of Our Lady of
Boulogne. Frith's model for the principal figure was the
Abbé Toursel and the vestments, robes, mitres, etc. were
supplied by Cardinal Manning.

attendants. Fortunately the room is an immense one, or it would have been filled; and of all the rows! – those children, shouting, laughing, and romping with the Princesses. I was looking at little Prince William, and talking to Princess Helena, when the royal imp looked up in my face and said: "Mr Fiff, you are a nice man; but your whiskers –", when the Princess stopped his mouth with her hand. He struggled to get her hand away, and again said – "Your whiskers –", when she stopped him again, blushing, and laughing till she could scarcely move. However, they carried the youngster to the other end of the room, and soon brought him back to good manners. The Crown Prince – who is one of the finest and most manly-looking figures I ever saw – sat for a while, and I did the outline of his head, and shall make a very successful thing of him. The Crown Princess comes on Tuesday, when I hope to get a nice likeness of her . . . Little Prince William calls the picture "Uncle Wales' Wedding". The Princesses always speak of the Queen as "Mamma", and they are altogether like a happy middle-class family . . .'

Although the antics of the 'little Turk', the 'royal imp', helped liven up Frith's reminiscences years later he must have proved an awful trial at times. He was about seven years old at the time, and to keep him quiet Frith let him paint in a small corner of his canvas, but one day as he was working quietly on part of his picture Frith was roused by an exclamation of alarm from the lady-in-waiting in whose charge the Prince always came to him. 'Look at his face!' she cried. 'What has he been doing to it?' Frith looked round and saw that the lad had been simply wiping his brushes on it; it was streaked crazily with vermilion, bright blue, and various other colours. 'What is to be done? If the Princess should see him she would . . .' 'Oh,' said Frith, 'I can easily remove the paint,' and so saying, he dipped some clean rag in turpentine and effectively rubbed off the colour. But, as he did so, he was stopped by violent screams from the 'royal imp'. The turpentine had touched a little spot or scratch on his face and given him great pain. With a parting kick he took refuge under a large table, and yelled his head off until he was tired, his attendant meanwhiles hovering about with the jitters, and in terror lest his screams be heard outside the room. Predictably, the lad played him up and sat so badly Frith 'failed in producing anything in the picture resembling him', he regretted. However, 'Willy' later became quite fond of the artist and when they met in the Long Walk at Windsor would greet him thus: 'Come and wide with me, Mistah Fiff.'

Frith left Windsor Castle but his picture stayed there. It was a severe winter and the days too short for serious work on it, anyhow. There are no records of any sitting in 1864 until we get to April, although his frequent train journeys from Paddington to Windsor in the interval doubtless helped him 'absorb the atmosphere' and study the architectural details of St George's Chapel to some effect, since, an entry in the Queen's Journal for 29 January 1864 reads: 'Mr

[94]

Frith is here again & the Picture has got on very much & is really a fine thing.'

— *3* —

As the season opened and London filled up again Frith hoped to entice more of his famous and titled sitters into his studio: 'My regard for truth compels me to say that they were not all beautiful, but one left little to be desired in that respect. Lady Diana Beauclerk, daughter of the Duke of St Albans, was not only beautiful, but as agreeable as she was handsome.' Frith also worked from photographs of her taken by the firm of Window & Bridge, whilst his daughter, 'Cissy', sometimes modelled in her place for the dress, arms and hands: not a chore she greatly cared for.

Frith doggedly worked through his list of sittings from ambassadors, bishops, statesmen, and their wives, as and when their other engagements allowed them to do so. Even so, he found it necessary on 2 May 1864 to draw up a blacklist of recalcitrant sitters from whom he could 'neither get photographs nor answers', and send it on to Sir Charles Phipps, with a heartfelt cry for his help; otherwise 'I fear I shall fail, and I can never thank you sufficiently for your kind offer to help me.'

Amidst all the needless difficulties and anxieties created by inconsiderate sitters Frith did, happily, find sitters who were not only co-operative but extremely pleasant and interesting to meet. None more so than the Hon. Frederick Byng – the 'Poodle' Byng of Captain Gronow's *Reminiscences and Recollections* – who regaled Frith with bins-full of anecdotes about Beau Brummell and the dandies of fifty years back. As he sat to Frith he chatted away about the last time he had sat for a painting of 'the wedding of the Prince of Wales' – of the future George IV to Princess Caroline of Brunswick, sixty-nine years before. Although he was well over eighty at the time of these sittings Byng walked from his residence in Duke Street, St James's, to Frith's Bayswater studio for the exercise and fun of it.

As Frith tells us, and we can see for ourselves in his painting, one of the most conspicuous figures at the wedding was the Maharajah Dhuleep Singh, who wore an Eastern dress of great splendour and was just about smothered in jewellery: 'I was about to say blazed with them – but the diamonds, being uncut, looked to me like bits of dull glass, with just as much glitter,' Frith writes. 'They had to be painted, however, and the Prince was willing to wear them; but, as they were of fabulous value, he was naturally reluctant to leave them with me; and he was only induced to do so on the condition that his servant remained with them, and with the understanding that they were to be deposited each night at Coutts's Bank. This the servant promised; but, seeing that I possessed a burglar-proof iron safe,

he trusted them to its keeping, and me with the keys, remarking: "Now, if the Prince knew of this, he would be awake all night." '

— 4 —

Before submitting his painting for the summer exhibition of 1865 at the Royal Academy, Frith felt it was right and proper that his royal patron should be given the opportunity to see the picture first, and made these views known to her through the usual labyrinth of court channels. On 27 March he received a telegram from Windsor which read: 'Be prepared for a royal visit to your studio tomorrow between twelve and one o'clock.'

There was intense excitement in Frith's household on receipt of this and the reticent account of the visit given in Frith's *Autobiography and Reminiscences* is agreeably supplemented by further details in the account also given by his daughter 'Cissy'. The Queen, who left Windsor for Paddington at 11.40 a.m., notes in her Journal that it was 'a fine bright morning & warmer'. Her party included King Leopold of the Belgians, the Princesses Helena and Louise; the Countess of Gainsborough and Lady Augusta Stanley. Two other artists' studios were to be visited also, and at 1.15 p.m. she was due to hold court at Buckingham Palace, so she was working to a somewhat closely-packed programme.

Frith's children had had a lot of practice bobbing up and down on the red sofa which commanded a view of the window and of the entrances and exits of a non-stop stream of notabilities for months now, but their excitement that morning was intense as mounted gentlemen and grooms kept calling with messages: 'The Queen will be here in half-an-hour . . . in twenty minutes . . . in ten minutes . . . The Queen is in sight.'

One thing the Queen never learnt, although we feel sure it would have amused her, was that 'the pretty, smart parlourmaid in orthodox cap, apron and black dress, who opened the gate to her', was Frith's sister, Vicky (so named because she was born, happily, on the Queen's birthday). She had hit on the idea of this innocent piece of play-acting to ensure that she got a really close view of the sovereign 'her loyal heart adored'.

'Cissy' recalls that as the Queen was introduced to her mother, Isabelle, a young member of the royal family blurted out, and in a rather loud voice: 'I didn't know artists lived in such big houses', only to be quelled into silence by one of the Queen's celebrated and disapproving looks. She did not stay long: 'found little or no fault, and left me with the impression that I had succeeded as well as could be expected, considering the great difficulties of the task', writes Frith.

The Flower Seller.

1865. 29 x 24 ins. Courtesy of Christies, London.

Seen at her stall with elegant company to the right.

Would Frith repeat the success of *Ramsgate Sands, Derby Day* and *The Railway Station*? After all, he had not shown anything at the Royal Academy for two years, and the public were curious. It soon became clear that he had; and, 'after a fight', the *Wedding* was provided with an iron rail to protect it from the press of over-eager visitors.

'In the depicting of such ceremonies, it is the executive, not the imaginative powers of the artist that are called into play', the *Morning Post* critic wrote, and praised the manner in which he had arranged his groups and kept a balance of colour and scale, whilst the *Art Journal*'s man spoke of the painting as a living and lasting chronicle of England's power, wealth and greatness.

Other critics were less complimentary, but since Frith never bothered to read reviews, either of the friendly or slighting variety, we, too, may forget them, especially since like most slanging notices, then as now, they appear to have been designed more to increase the notoriety of the big-head critic than to inform the public about the painting or the artist's intentions. Early in his career Frith had settled for the consolations of philosophy on such occasions, and for crying all the way to the bank with his patron's cheque in his pocket. His considered views of this subject are bodied forth in an early passage in his *Autobiography*:

'I would here advise all artists, young and old, never to read art criticism. Nothing is to be learnt from it. Let me ask any painter if, when he wants advice upon any difficulty in the conduct of his work, he would seek it from an art critic? No, I reply for him; he would apply to an artist friend. But though, as I believe, no advantage accrues in any case to an artist from public criticism, much undeserved pain is often inflicted, and even injury caused, by the virulent attacks that sometimes disgrace the press. For very many years – indeed, ever since I became convinced of the profound ignorance of the writers – I have never read a word of art criticism. "That accounts for your not painting better", I hear the critic say. I think not; but I have no doubt saved myself from a good deal of annoyance.'

As they do say: it takes a worried man to sing a worried song!

The Wedding of the Prince of Wales hangs at Windsor Castle today and not far away from G. H. Thomas's smaller, less ambitious painting covering the same event; but whereas Frith captures the precise moment when the Prince and Princess plight their troth facing the clergy and the high altar in St George's, G. H. Thomas's effort concentrates on events a few moments later, when, the ceremony over, the bride and bridegroom have turned round to face the ordeal of processing their way out through a sea of guests towards the west door through which they had entered, and what must have seemed to both of them, an eternity

[98]

ago. There is a smaller replica of Frith's work in the Walker Art Gallery, Liverpool.

But, *pace* Frith's own views as to the value of critics' opinions, we feel that Jeremy Maas's conclusions after his extensive researches into the circumstances surrounding the commissioning and execution of *The Wedding*, are obviously of great merit and deserve special consideration. He writes: 'To some extent, Frith's great picture at Windsor disarms criticism; it is so very patently the representation of a great state occasion painted to order. But one can admire it nonetheless for its coherence as a composition, for the handling of the paint, particularly in the architectural details of the chapel, while even the tiniest countenance proclaims itself a portrait.'

He suggests that Frith's two years' ordeal in producing this work wore him down so much that he never quite got back on form again or displayed any of the old zest so much in evidence in *Ramsgate Sands* and *Derby Day*. Well, none of us remain twenty-five for ever, and it is somewhat unfair, I feel, to expect artists and novelists, say, to continue at the top of their form all the time and for nearly twenty to thirty years after the normal professional man feels himself quite justified in retiring to do little else than read *The Times*, and play golf.

Certainly, the strain and downright obstruction he met with as he struggled to do justice to his task wore down even so bouncy and resilient a man as Frith, and it doubtless told on his health. 'I believe that a more difficult task never was undertaken by any man', that seasoned courtier, Sir Charles Phipps, wrote to Frith. That poor, bewildered man never claimed to know much about painting, let alone the way artists worked, or the baffling nature of their copyright dealings with their Gambarts and Flatows, but for months on end he must have felt at times like a football being leisurely kicked around on the one side by Eastlake and Frith, and on the other, by Lady Augusta and his sovereign. He certainly knew what he was talking about and his words must have been infinitely precious to Frith.

Let us visualize him, tired and clearly frayed around the edges, reading that cherished encomium from Phipps, before dropping his letter soundlessly upon the table before him, and, as he lights yet another cigar, murmuring to himself through clenched teeth: 'You can say *that* again!'

[99]

The White Dress.

1882. 12½ x 9½ ins. Courtesy of M. Newman Ltd., London.

CHAPTER EIGHT

Master of the Crowd Scene

EARLY IN APRIL 1866 ERNEST GAMBART decided to throw a party; a fancy-dress ball on a grand scale, rather, on the evening of Derby Day (16 May) at his St John's Wood home, 62, Avenue Road. He scattered invitations for it far and wide; to artists of various nationalities, and their wives; to writers, musicians, and actors; to members of his own family. Wardrobes were ransacked, theatrical costumiers besieged, and histories of costume diligently consulted. E. M. Ward and his family decided to show up in Elizabethan finery of the kind so often sported by the figures in his narrative pictures and in preparation for it sewing machines whirred continuously in the Ward household for weeks, whilst Frith, with *Charles II's Last Sunday in Whitehall*, freshly commissioned by Gambart for 3,000 guineas, found himself inveigled into the idea of going to the party as John Evelyn. His well-endowed wife, in a dress of lace and yellow satin, settled to appear as one of the court ladies in the Charles II painting. 'Cissy' seized on her great-grandmother's wedding-dress to alter and adapt for her chosen role as Dolly Varden: the subject of one of her father's earliest successes which helped notably to cement his much-cherished friendship with Dickens.

Frith needed a lot of persuasion to dress up since he had no love for what actors called 'leg parts', especially since he was haunted by uneasy fears of getting his legs tangled up with the damn-fool sword he would have to trail around all the time to keep 'in character'. He usually did!

Preparations were nothing if not thorough, and these included getting Messrs. Greenaway's to instal a mass of temporary wide lead gas pipes which were to be fed by a large meter in the billiards-room below the picture-gallery where the dance would be held. Gambart's foreign guests, who began descending upon him in St John's Wood included Alma-Tadema and his French wife. Mrs Frith and 'Cissy' helped Gambart's wife, Annie, with the flower-arrangements and all those innumerable little tasks which crop up and require to be done in the exciting run-up and preparations for a really big party. However, in the midst of these

preparations, Gambart looked in and whisked them all away from a tour of the tents in the spacious grounds of the house; and everywhere they went they kept seeing those endless bits and pieces of gas-piping and rubber tubing.

In the ballroom itself, with its highly-polished parquet floor, a version of Frith's *Derby Day* occupied a place of honour, whilst a large vacant space stood ready to take Holman Hunt's *The Finding of the Saviour in the Temple*, due to arrive early next morning. Naturally, the kitchen staff were in a great flurry of activity, and, indeed, an extra hand had been taken on: Mrs Etall, a forty-five year-old mother of six. In the marquees, James Bull, one of Greenaway's gas-fitters, kept darting about checking gas-pipes, tightening rubber tubes, and sniffing the air every so often to ensure there were no suspicious gas leaks anywhere. One way and another it had been a pretty busy and exciting day and no one, we imagine, was sorry to get to bed that night.

On the eve of the ball itself Gambart, who had spent the evening out, did not get back until midnight, when, he stated later, he was let in by Anne Waters, his parlourmaid, whom he told to turn off the two meters in the house: the one in the pantry, the other in the billiards-room. He himself saw to the jets on the landing and went to bed.

When Charlotte Habbit, the cook, got up at six to get ready for the great day, she told Mrs Etall that she could smell gas. Anne Waters thought there was a smell of gas, too, and, finding a lamp burning on the first floor, she turned it off and told the cook she had done so. Thinking no more about it she went back to bed. Mrs Etall descended later, lit the fire in the kitchen, and set about making tea for the staff round about 7.25 a.m. The moment she woke up, Anne Hymes, the housemaid, said she smelt gas. The sequence of events thereafter is best summarized in Jeremy Maas's words:

'Now, while all the rest of the household lay huddled under their bedclothes, others began to arrive, the first two, Violet, the gardener and Mitchell the French polisher, at half-past seven. Violet went into the house to get the key to the conservatory, and was met by Mrs Etall, who had also been discovered making breakfast in the kitchen at a quarter to eight by Albert Coulter, Gambart's coachman. On entering the conservatory Violet instantly smelt the same sinister fumes. Mitchell had come by the kitchen door, and then had gone into the pantry. It was quite dark. On entering the gallery from the dining-room, and noticing the smell of gas, he opened the glass doors and a revolving iron shutter. Then he met Violet, who asked him and Anne Waters, who had by now appeared with Mrs Etall, to open all the windows. Violet had looked at the pipes in the gallery and satisfied herself that the gas had been turned off.

'It was now about six minutes to eight. Waters anxiously asked Mitchell if *he* could smell gas. When he assured her that he could, she told him breathlessly

Gambart 'at home' May 16th '66.

1866. Courtesy of Jeremy Maas.

A lightning impression by Philip Hermogenes Calderon of
Gambart calmly sitting in the grounds of his ruined home
at a small table on which rest an inkstand and a tea-set.

that the smell of gas in her bedroom was so overpowering that she had had to open the door. Determined to discover the source of the deadly fumes, Waters rushed out of the gallery, picked up a box of lucifers, and went into the billiards-room below the gallery. Here the smell was even stronger, and, on seeing a pall of blue vapour obscuring the ceiling, she lit a match to see it more clearly. She saw something "like a flash of lightning", and remembered no more.'

— 2 —

The explosion was heard for miles around. Within seconds the entire back of Gambart's house lay in ruins; huge chunks of masonry and heaps of bricks were thrown hundreds of feet in the air, whilst pictures and statuary were tossed crazily about like toys in Hamley's store. The air became rent with screams from the violently awoken guests in a house where everything seemed to be oddly in movement, and furniture and ornaments kept crashing down everywhere.

Violet, the gardener, relieved at finding herself unhurt after the shock of the explosion, hurried to the kitchen where she found Mrs Etall buried in the pantry, a large section of brickwork lying heavily on her stomach and legs, her dress on fire. She managed to put out the flames and got the poor, crushed body out into the stableyard. The Alma-Tademas, who had woken earlier and before the explosion, had the sense on smelling gas to open all the windows, but clung to one another in terror when the crash came and their bedroom lurched to one side crazily on impact. One macabre feature of the ensuing bedlam which greeted the ears of the sleep-bemused guests as they tried to take in the situation was the frenetic, bewildered shrieks from the exotic birds in Gambart's much-admired aviaries in the grounds. Men in nightcaps and ladies in curl-papers had been flung about violently, some of them even landing on top of wardrobes, and in no time at all the corridors were full of frightened, uncomprehending people in varying states of disarray, all shouting and gesticulating at once and in a dozen different tongues.

Gambart after being violently woken up, like everyone else, hastily flung on a dressing-gown and shot downstairs to view with dismay and disbelief a scene of utter chaos. One of the first people he saw was his coachman, Coulter, lying bleeding on the grass, and servants scurrying about everywhere, many of them still in their night-clothes. When Annie Gambart tottered on to the scene in a state of near-collapse Gambart whisked her away to safey at a friend's house at short distance down the road.

Although the explosion had occurred so early in the day crowds began to converge on the scene, but, fortunately, the police were able to keep them at a

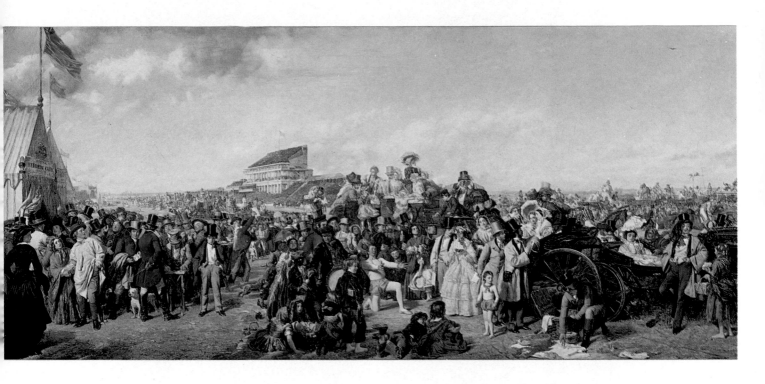

PLATE FIVE: *Derby Day*.

1858. 40 x 88 ins. Collection: Tate Gallery, London.

This was the sensation of the Royal Academy Exhibition of
1858 and is the most frequently reproduced of all Frith's
works. He painted several versions of it in varying sizes.

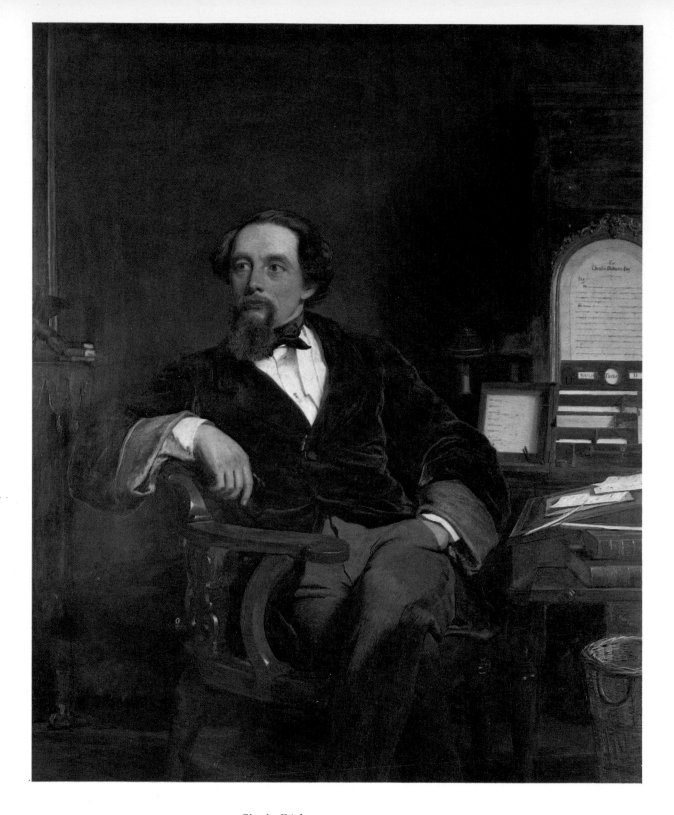

PLATE SIX: *Charles Dickens*.

1859. Canvas. 27½ x 22 ins. Collection: Victoria & Albert Museum.

A sensitive portrait of Frith's close friend the writer Charles Dickens.

PLATE SEVEN: *Feeding Time*.

1850. 35½ x 27 ins. Collection: Sotheby-Belgravia, London.

Painted in association with Richard Ansell, R.A.

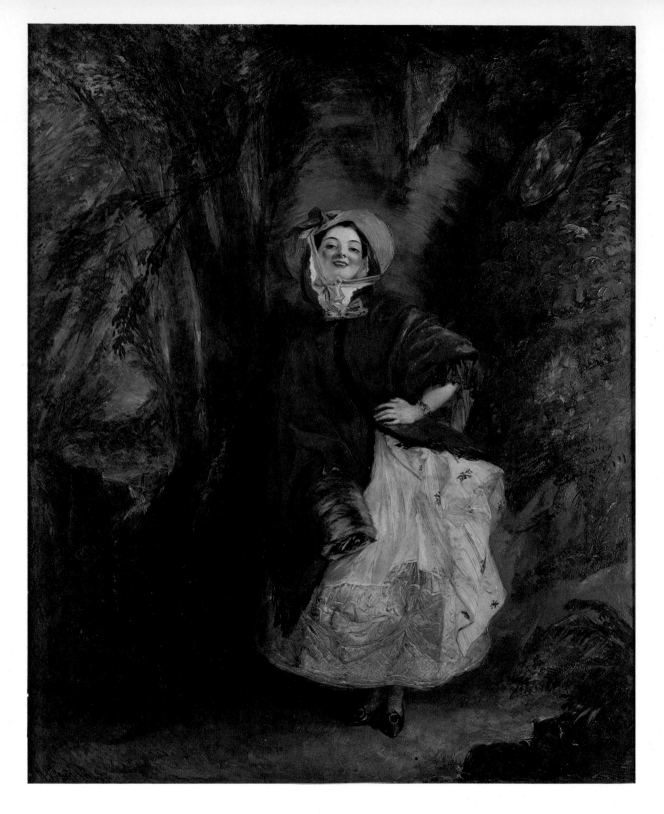

PLATE EIGHT: *Dolly Varden.*

1842. Canvas. 21½ x 17½ ins. Collection: Victoria & Albert Museum.

One of the many illustrations for Dickens' novels commissioned from Frith by the author himself.

distance as frantic rescue-operations were put in hand. Mrs Etall was rushed off to St Mary's Hospital, Paddington, and at 8.20 a.m., a fire-engine appeared with a great clanging of bells and a clatter of hooves, but by this time the fire had been brought under control. The firemen concentrated on trying to locate the cause of the explosion.

Frith's *Derby Day* replica, fortunately, escaped with only slight damage, but Alma-Tadema's *Egyptian Games* suffered badly. Gambart, by this time fully-dressed in frock-coat and top-hat, found the canvas covered with blisters from the heat. 'Here is the end of my picture', cried Alma-Tadema. However, he did restore it quickly and it is to be found now in the Preston Art Gallery and with a new title, *Pastime in Ancient Egypt*. The old cracks have reappeared in it, though, and Mr Maas speaks of it as 'beyond hope of permanent restoration'. Clarkson Stanfield's *Bass Rock* was wrenched from its frame, hurled through the gallery skylight, and wound up in Robert Lush's garden, whilst two of Creswick's paintings were found on a neighbour's iron railings. The only piece of luck, if that is the right word in such a context of disaster, was that Holman Hunt's *Temple* picture had been on its way to Gambart from the West End at the time of the explosion, and so escaped damage.

As the day went by the news spread and more and more crowds materialized in St John's Wood. One of these was Philip Hermogenes Calderon, the artist, who made a striking drawing of Gambart calmly sitting in the grounds of his ruined home at a small table on which rest an inkstand and a tea-set. He is unconcernedly sipping tea! Calderon entitled his sketch: *Gambart 'at home' May 16th – '66*. The drawing, which passed into the possession of G. D. Leslie, and then to his descendants, is now in the possession of Mr Maas and reproduced by him in his book on Gambart. Somehow, this unpretentious sketch captures the quality of this impresario-dealer's courage under desperate circumstances and tragedy more effectively than any canvas.

There was an inquest, naturally, and yards about the disaster in the newspapers and periodicals like the *Illustrated London News*. Anne Waters had hideous burns on her face and neck but was in a less critical state than poor Mrs Elizabeth Etall, whose injuries proved so extensive that she died after her admission to St Mary's Hospital at 12.30 p.m. The jury gave it as their opinion 'that the gas fittings on the occasion of the explosion of gas which had killed the said Elizabeth Etall were carelessly made and left . . . they have not sufficient evidence to show that this was the cause of the explosion'. They settled for a verdict of 'accidental death'.

A few months later Gambart *did* give his promised fancy-dress party – at Willis's Rooms in King Street, Covent Garden – which was cheerful enough on the surface, but somehow the memory of those ghastly events so shortly before could never have been far from the minds of Gambart's guests that night.

Nell Gwynne at Drury Lane.

1869. 24 x 20 ins. Courtesy of The Leger Galleries, London.

Frith was never a man to spend overmuch time on deep philosophic thought but he must have been struck by the coincidence, none the less, that at the original party which Gambart planned he had intended to go as John Evelyn and that the impulse to do so came from the painting which Gambart had commissioned him to do and which illustrated the following passage from Evelyn's *Diary* in which he described how he and two friends paid a visit to the old Palace of Whitehall on the Sunday evening just before the death of Charles II. Evelyn writes:

'I can never forget the inexpressible luxury and profaneness, gaming and all dissoluteness, and, as it were, total forgetfulness of God (it being Sunday evening) which this day se'nnight I was witness of. The King sitting and toying with his concubines – Cleveland, Portsmouth, and Mazarin; a French boy singing love-songs in that glorious gallery; whilst about twenty of the greater courtiers and other dissolute persons were at basset round a large table – a bank of at least two thousand pounds in gold before them – upon which two gentlemen who were with me made reflections with astonishment. Six days after was all in the dust.'

Frith's preparations for the painting and the research into details of costume and regalia were as thoroughgoing as ever; and, naturally, he supplies us with many of these in his *Autobiography*. They conclude triumphantly thus: 'Monday, June 4, '67 – To R.A., where I find a rail round the *Charles*, to my great surprise and pleasure. This is the third rail round my work in the Exhibition – first the *Derby Day*, then the *Royal Marriage*, and now *The Last Sunday of Charles II*. Eureka!'

— *3* —

On a visit to Baden in 1843 the gaming-tables were in full blast and Frith recalls a strong desire 'to strike out a picture from them; but the subject appeared to me too difficult to be undertaken without much more experience, than I had at the time'. When, however, he discovered in 1869 that his friend, O'Neil, intended to visit Homburg and found also that the tables there were to be closed down in two years time he felt it was a case of 'now or never' if he was ever going to tackle a true representation of a scene depicting a miscellaneous crowd of people caught up in the siren toils of gaming-fever, and with the play of masked emotions registered in their features against an authentic background. In a letter to his sister Frith wrote:

'My first sight of the clustering crowd round the tables shocked me exceedingly. Instead of the noisy, eager gamblers I expected to see, I found a quiet, business-like, unimpressionable set of people trying to get money without working for it – some, perhaps, playing to gratify the excitement of the gambling spirit, and

indifferent as to the result, but the motive of the majority appeared to be a vulgar greediness after the stakes . . . I confess to a love of gambling, though I deny altogether the disposition to make money by it, and, shocked though I felt at the crowd round the tables in the Salon d'Or, I very soon made one amongst them – see the demoralizing effect! – but, as I never staked gold, I gratified my excitement without much risk. Great numbers of thalers I won, and as I continued gambling, I lost them all as a matter of course.

' "*Soyez content d'un peu*", said the good-natured croupier.'

Frith could not have agreed more! Indeed, he went one better and exchanged the role of participant altogether for that of onlooker: 'and amused myself by studying the people with a view to the picture which afterwards appeared at Burlington House under the title of *The Salon d'Or*. The picture was so popular as to require the protection of a rail, and I can truly say in its favour that, whatever may be its merits or demerits as a picture, it is a strictly true representation of a scene passed away for ever . . .'

The painting was bought by a Mr Roffey with a view to being engraved for publication, but Frith doubted if a worse print was ever made from a figure-picture: 'the failure was complete'. The engraver engaged by Mr Roffey, he explains, was a man who had acquired some eminence when the subject chosen was of a dog or a horse, 'but whose experience in respect of the human animal was so slight that he was quite at sea in his attempts to reproduce my unfortunate gamblers'.

Frith had large photographs taken of the gaming-room, and even wrote his chapter about *The Salon d'Or* as he sat in one of the chairs he had brought back from the gaming-room. He also secured one of the croupier's rakes and empty rouleau-cases, with other material necessary for his composition. He explains that in the immediate foreground sits a roué who turns to a lady standing by him, with whom he seems to have tender relations, and places in her hand some bank-notes – 'evidently – from his smiling countenance – the results of his winnings. The lady receives the money, but whether for the purpose of risking it again or not, does not appear. The model for the lady was a handsome dark girl, whose name I forget. She was a rather stupid person . . .'

The painting is now in the museum of the Rhode Island School of Design: the gift of Mr Walter Lowry. A smaller version of the painting appeared in an exhibition held at the gallery of M. Newman Ltd., Duke Street, St James's, London, S.W.1, entitled *The Victorian Scene* in 1962 (14 November–14 December) and is reproduced in colour in the exhibition catalogue. It aroused much interest at the time, notably in *The Connoisseur* (November 1962), where it was discussed by Adrian Bury in the galleries feature he did regularly for the magazine in those days, and in the December issue of *Apollo*, by Mario Amaya. But the most useful

contribution sparked off by the reappearance of this smaller version of *The Salon d'Or* was, perhaps, that which appeared in the quarterly *Bulletin of the Rhode Island School of Design* (No. 50, No. 3) in which Elaine P. Loeffler was able to take advantage of her familiarity with both paintings and supply us with some illuminating comments on them both.

At first glance, she tells us, both versions looked almost identical, but on closer examination significant and revealing differences between the two paintings could be detected. She writes: 'In the Museum's version there is a pervading stillness, a hint of tragedy, a moralising tone. The smaller painting is far more active, more immediate and totally lacks the foreboding atmosphere of the larger painting. The human types represented account in large part for these differences.'

Miss Loeffler particularly instances the couple in the left foreground, the seated man and the standing woman already mentioned by Frith himself: 'In the large painting, a handsome bearded young man turns about to look imploringly at a pretty young woman standing behind them; he appears to be taking money from her hand. One can easily sense that tragedy is involved.' In a footnote she adds that a writer in the *Illustrated London News* at the time of the Royal Academy exhibition of 1871 wrote: 'An excited young swell in the foreground, who, having lost all, is drawing a subsidy from his reluctant female companion is one of the most telling points in the picture.'

In the smaller version, though, a smiling man, not at all handsome, seems to be giving rather than taking money from the woman, 'with whom', as Frith told us, 'he seems to have tender relations', and which, on the evidence of his smile, represents the sum of his winnings. The man in the museum's painting does not smile, but the one in the smaller version does. Puzzled? This is understandable, and it highlights one of the dangers of taking anything Frith writes too much on its face value. His reminiscent volumes were, remember, written in old age, and the artist obviously relied on his memory which played tricks with him, as it does with us all. Moreover, since he made no pretensions to being a precise, professional historian, he never bothered to check or look anything up when he wrote. In short, his description in his *Autobiography* of this painting is not, as *he* thought, of his finished Academy offering at all, but of his 'trial run'; the initial smaller version!

Commenting on further noticeable changes in the two versions Miss Loeffler reminds us that the devilish-looking fellow in M. Newman Ltd.'s painting, who sits across the above-mentioned couple becomes transformed into a worried-looking gambler in the final version. The man to the croupier's left in the museum *The Salon d'Or* looks serious whereas in the smaller version he smiles with pleasure. 'Even the piles of chips in some cases appear to have shrunk in the time elapsed between the two versions', she writes, and wonders if the smaller version does not

correspond more to what Frith actually saw at Homburg in terms of atmosphere and spirit than the later work which went on view in the Royal Academy and in which Frith is concerned more with getting across a moral statement than in simply recording pictorially a 'slice of life'.

She concludes thus: 'Despite the identity of composition and setting in the two paintings, then, they are actually quite different. It would appear that while artists in France at this time were analysing colour and form, Frith was analysing human frailty.'

An amusing tailpiece to this fascinating exploration of the differences between the two versions of *The Salon d'Or* is supplied by Frith himself who tells us that Homburg was 'the innocent, or wicked, cause of another small artistic effort of mine. It was not uncommon to see ladies sitting among the orange-trees smoking cigarettes. I was attracted to one – a very pretty one – who, her efforts to light her cigarette being unavailing, called to the waiter for a light. A candle was brought, and as the fair smoker stooped to it she presented such a pretty figure, and altogether so paintable an appearance, that I could not resist a momentary sketch, afterwards elaborated into a small picture . . . I was mercilessly attacked for painting such a subject at all.'

Frith was ruefully aware of the great gulf which existed between what was deemed socially permissible in mid-Victorian days to a painter and what Hogarth had got away with earlier. As Jerome K. Jerome observed about a play he wrote in collaboration with Eden Phillpotts called *The MacHaggis*: 'Our heroine shocked the critics. She rode a bicycle. It was unwomanly, then, to ride a bicycle. There were so many things in those days, that were unwomanly to do. It must have been quite difficult to be a woman, and remain so day after day. She smoked a cigarette. The Devil must have been in us. Up till then, only the adventuress ever smoked a cigarette. In the last act she said "damn". She said it twice. Poor Clement Scott nearly fell out of *The Daily Telegraph*.'

— *4* —

'Beyond the desire of recording for posterity the aesthetic craze as regards dress, I wished to hit the folly of listening to self-elected critics in matters of taste, whether in dress or art. I therefore planned a group, consisting of a well-known apostle of the beautiful, with a herd of eager worshippers surrounding him. He is supposed to be explaining his theories to willing ears, taking some picture on the Academy walls for his text. A group of well-known artists are watching the scene. On the left of the composition is a family of pure aesthetes absorbed in affected study of the pictures. Near them stands Anthony Trollope, whose homely figure

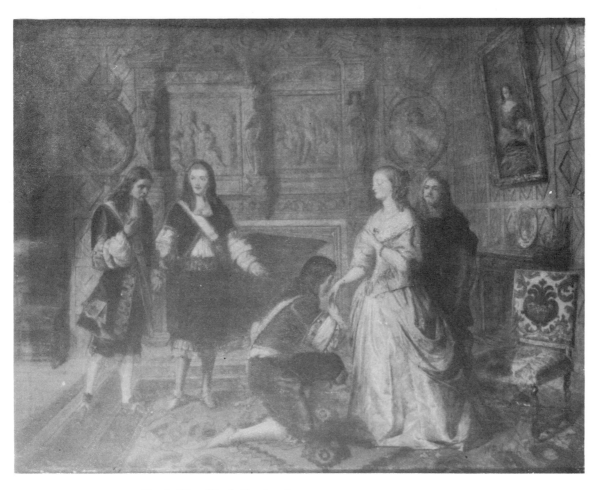

Charles II and Lady Castlemaine.

1899. 10 x 12½ ins. Courtesy of Sotheby-Belgravia, London.

The theme of this picture was suggested by the following passage from Pepys' *Diary:* 'Mr Pierce, the surgeon, tells me that, though the King and my Lady Castlemaine are friends again she is not at Whitehall but at Sir D. Harvey's, whither the King goes to her; but he says she made him ask her forgiveness on his knees, and promise to offend her no more so, and that, indeed she hath nearly hectored him out of his wits.'

affords a striking contrast to the eccentric forms near him. The rest of the composition is made up of celebrities of all kinds, statesmen, poets, judges, philosophers, musicians, painters, actors and others.'

Thus Frith on his prize offering in the Royal Academy's summer exhibition of 1883: *The Private View at the Royal Academy, 1881*. Agreed, the *mechanics* of the thing were as impressive as ever, no doubt; the artist's industry formidable and to be treated with a respect mandatory in an age which extolled the virtues of hard work – and yet, an uneasy suspicion crept into the minds of many viewers that something of the old magic which had informed *Derby Day*, *The Railway Station* and the *Royal Wedding* paintings was missing. It was doubtless academically correct and the various groupings within the painting ingenious, but the nagging doubts persisted. However, as the record Frith intended it to be, it has remained ever since of enormous interest and value to students of the social scene, and it is from that angle that it can best be studied and discussed today.

It may be, because he was so anxious to establish the thesis that work on *Royal Wedding* nearly killed Frith creatively, that in his book on the painting, Mr Jeremy Maas is so severe on the *Private View*: 'a rather too fashionable deference to the brown tones of Orchardson and a certain dryness in the handling show only too clearly that Frith had lost his old mastery ... only the plenitude of celebrities and their careful grouping beguile the onlooker. The artistry of *The Derby Day* had capitulated before the mechanics of reportage.'

The trouble here is the familiar one which haunts the later years of successful painters and novelists: the fear that they may fall out of fashion. Ironically enough, success carries within itself the seeds of danger; of provoking the perverse scorn of rebellious youth which needs must scorn the idols their parents revere. And, historically speaking, Oscar Wilde's conspicuous presence in the *Private View* is especially significant in view of the Frith family's close association with editors of *Punch*, like Shirley Brooks, its contributors and artists, and the fact that nowhere was the Aesthetic Movement subjected to greater ridicule than in *Punch*, where George Du Maurier had a fine old time of it making fun of Mrs Ponsonby de Tomkyns and her pursuit of 'cultchah'; her crazy ambition to attract to her drawing-room evenings the Cimabue Browns of Passionate Brompton. Visitors to Burlington House when the *Private View* went on show and became a talking-point would have been only too familiar with *Punch*'s tilt at the Grosvenor Gallery and all its long-haired devotees:

> The haunt of the very aesthetic,
> Here come the supremely intense,
> The long-haired and hyper-poetic,
> Whose sound is mistaken for sense.

[112]

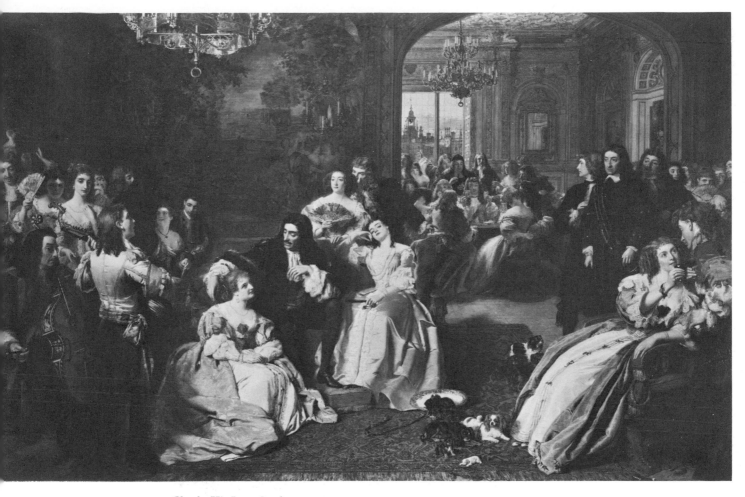

Charles II's Last Sunday.

1867. 66¼ x 102¼ ins. Courtesy of The Leger Galleries, London.

This painting, exhibited at the R.A. in 1867 and 1911, and at the Paris Universal Exhibition in 1878 depicts a scene recorded by Evelyn in his *Diary:* 'I can never forget the inexpressible luxury and prophanenesse, gaming and all dissoluteness, and as it were total forgetfullnesse of God (it being Sunday evening) which this night se'nnight I was witnesse of; the King sitting and toying with his concubines, Portsmouth, Cleaveland, and Mazarine, etc., a French boy singing lovesongs in the glorious gallery, whilst about twenty of the greate courtiers and other dissolute persons were at basset round a large table, a bank of at least £2,000 in gold before them, upon which two gentlemen who were with me made reflexions with astonishment. Six days after, was all in the dust.'

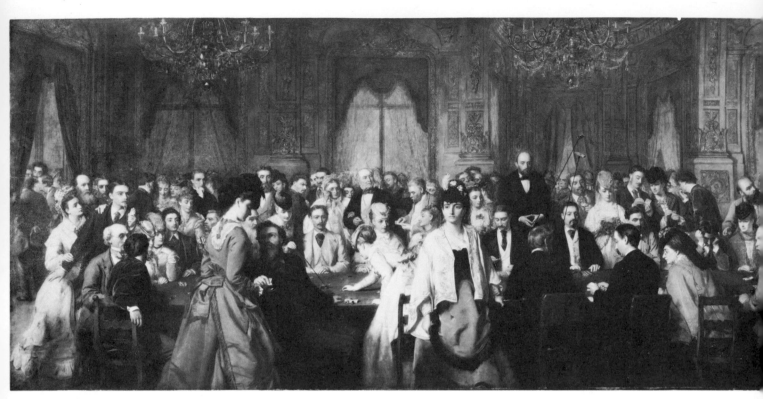

The Salon d'Or, Homburg; Le Jeu Est Fait, Rien Va Plus.

1871. 17½ x 35½ ins. Courtesy of M. Newman Ltd., London.

This is in fact a smaller version of the original painting exhibited by Frith in the Royal Academy Exhibition of 1871.

At Homburg.

1870. 23 x 19 ins. Courtesy of Christies, London.

The Private View at the Royal Academy, 1881.

Courtesy of the Royal Academy of Arts, London.

'Beyond the desire of recording for posterity the aesthetic craze as regards dress, I wished to hit the folly of listening to self-elected critics in matters of taste . . . I therefore planned a group, consisting of a well-known apostle of the beautiful, with a herd of eager worshippers surrounding him. He is supposed to be explaining his theories to willing ears, taking some picture on the Academy walls for his text. A group of well-known artists are watching the scene. On the left of the composition is a family of pure aesthetes absorbed in affected study of the pictures. Near them stands Anthony Trollope, whose homely figure affords a striking contrast to the eccentric forms near him.' The 'apostle of the beautiful' referred to in this extract from Frith's *Autobiography* was intended to be a caricature of Oscar Wilde.

And many a maiden will mutter,
 When Oscar looms large on her sight,
'He's quite too consummately utter,
 As well as too utterly quite.'

As 'Cissy' observed, Frith family likenesses abound in old volumes of *Punch*: 'People who recollected my aunts in their youth say such beautiful creatures were never seen. When they rode or walked out they were followed, and it is a curious coincidence that while John Leech put them into his pictures in *Punch* Du Maurier did the same for our generation, and I and my sisters and one brother are enshrined in nameless yet deathless fame by his pencil in some of the numbers from 1867 onwards.'

It was in 1878 that Oscar Wilde came down from Oxford with First Class Honours and the Newdigate Prize for poetry to act as his own public-relations trumpeter in the drawing-rooms of Mayfair and Belgravia. At Oxford he had listened to Ruskin, and even found himself inveigled into navvying on the Hinksey Road, (the sight of this floridly handsome young Irishman in his *outré* poetical clothes wielding a pick-axe, must have alone been worth going to Oxford to see!); but then he 'discovered' Walter Pater and began to copy his life-style and re-echo his sentiments; his languor even, his interest in gems and precious stones; to collect the blue china, the vogue for which had been started by Rossetti and Whistler. 'I must live up to my china', he lisped in his Oxford rooms, where he burnt incense, naturally, since Pater did. His devotion to *Pater noster*, teetering as it did on the verge of sheer caricature of the master must have at times become an acute embarrassment to the author of *Marius the Epicurean*.

Another *Punch* editor who enjoyed himself satirizing Wilde was F. C. Burnand. In *The Colonel*, the character of Lambert Stryke, as played by Beerbohm Tree, became instantly recognizable as Wilde. This is the play in which the leading lady, lets fall with all the intense ardour of one utterly, utterly devoted to 'cultchah' those memorable words: 'There is so much to be learned from a teapot.' And whilst Burnand's play was still doing good business Gilbert and Sullivan moved in at the Opera Comiqué on 23 April 1881 with *Patience; or Bunthorne's Bride*.

Durwood Lely played Bunthorne, the florid-fleshy poet, the rival of Archibald Grosvenor, the 'spoony' poet, for the hand of the village milkmaid, Patience. Durwood Lely's part was modelled carefully on Whistler, down to his monocle, whilst Archibald Grosvenor was obviously Wilde:

Though a Philistine may jostle, you will rank as an apostle
 in the high aesthetic band,

[117]

If you walk down Piccadilly with a poppy or a lily in
you medieval hand.

Wilde had done just that, of course, attired in a Byronic collar of a loose-flowing kind, a large knotted green tie, velvet knee-breeches, silk stockings and a velvet beret. He fondled a madonna lily which he was taking in a gesture of homage to place in the hands of the town's presiding beauty: Lily Langtry. She figures in Frith's painting, naturally, with Ellen Terry, Sir Henry Irving, and other stage celebrities.

It will be recalled that in *Patience* the chorus of soulful maidens scorn the attentions of the army officers attired in the so, so obvious glories of scarlet and such-like primary colours; they would have been much more acceptable in 'a cobwebby grey velvet, with a tender bloom like cold gravy'. No, their hearts went out to . . .

A Japanese young man,
A blue and white young man,
Francesca di Himini, miminy-piminy,
Je-ne-sais-quoi young man!

A pallid and thin young man,
A haggard and lank young man,
A greenery-yallery, Grosvenor Gallery,
Foot-in-the-grave young man!

Punch and Gilbert and Sullivan capitalized on the Aesthetic Movement by taking it apart and laughing at it, but one young man who watched it with serious interest from behind his counter at 218, Regent Street was Arthur Liberty. Here is a description of Liberty's Umritza Cashmere which the firm introduced in 1879 from the *Queen* magazine: 'There are tints that call to mind French and English mustards, sage-greens, willow-greens, greens that look like curry, and greens that are remarkable on lichen-coloured walls, and also among marshy vegetation – all of which will be warmly welcomed by those who indulge in artistic dress or in decorative revivals.'

Frith's *Private View*, which perpetuates on canvas his 'desire of recording for posterity the aesthetic craze as regards dress', may well amuse us today, but it should never make us too scornful of fashion's slaves. As Lady Bracknell observed: 'Never speak disrespectfully of Society, Algernon. Only people who can't get into it do that.'

CHAPTER NINE

'Ill advised attempts to rival Hogarth'

FOR A LONG TIME FRITH HAD TOYED with the idea of painting a series of pictures illustrating the sad results of a young man's addiction to gambling. He began, as ever, with a number of chalk-studies and preliminary sketches which formed the basis of what became a series of five paintings grouped under the collective title of *The Road to Ruin* and which were shown at the Royal Academy exhibition of 1878. The paintings, measuring 28 × 36 inches, are now in a private collection in Italy.

It was, says Frith, to be a kind of gambler's progress, but, 'avoiding the satirical vein of Hogarth, for which I knew myself to be unfitted'. In the first scene Frith's hero is seen entertaining a set of his cronies in his college rooms. They have been playing cards all night. One young fellow, wisely perhaps, has dropped off to sleep on a sofa and out of the game. His companions, though, continue to play furiously, albeit another non-player draws the curtains to reveal that a fresh day dawns; the fitful rays of the rising sun light up the towers of the college opposite. Another guest blows out a candle. It is required no longer. Frith visited a Cambridge undergraduate's rooms in search of an authentic setting for this picture, and also had photographs run off to help him build up his scene. The tower glimpsed from the window is reminiscent of the main gateway to Caius College by Alfred Waterhouse.

In the second painting our solo whist stripling of the earlier scene has moved rapidly down the primrose path and into the Marquis of Hastings' league since there we find an older, wiser man vainly trying to dissuade our hero from having anything to do with the ingratiating touts who tempt him from the plebeian side of the royal enclosure at Ascot. Christopher Wood plausibly suggests that one of the fashionably-dressed ladies on the extreme right of the picture could well be meant for the gambler's wife.

The third painting makes it clear that the touts have done their worst to the drawling dandy at Ascot since here are the bailiff and his minions at his ancestral

[119]

home. The young man tries to bluff it out as he lolls, with a show of dandaical unconcern in a fashionable yet carelessly-worn dressing-gown against a mantel-piece surveying the invading party with cool insolence. One of the bailiff's men looks with a quiet sense of pity and understanding towards the surprised mother and her two children playing unconcernedly with their toys. Through an open doorway two servants are clearly discussing this unusual development in their lives, and, maybe wondering if they are likely to see much of their wages. We suspect these are already well in arrears. A copy of the sportsman's Bible, *Bell's Life in London* casually litters up the fireplace.

By the fourth painting the scene has switched to France where the hero has flitted to escape his creditors, and where he is cornered, seated like Hogarth's 'Distress'd Poet', and struggling to complete a play (another gamble; 'bound to succeed'), whilst his wife, in the best traditions of beleaguered gentility, en-deavours to shore up the family's fortunes by painting watercolours (ye gods!). The son tries to comfort his poor, harrassed father whilst the daughter resignedly settles for warming her hands at the fire. Behind the door we glimpse a cradle. Thus it would seem that our haunted, hunted couple have been saddled with the problem of yet another mouth to feed since they fled England.

In the final painting the end is very close indeed. Back in a London garret, the ruined, cornered man has locked the door. On a table, bang centre in the painting, lies a loaded gun. A letter, absent-mindedly litters the floor and has been placed there to inform us that the Theatre Royal, Drury Lane, has no use for the hero's comedy. The chaotic state of the room accentuates the grim moral of Frith's five-part fable. The wicker cradle, the broken toys, hint at the anguish and privations endured by the gambler's wife and children as a consequence of the hero's selfish folly. Frith found the furniture for this painting in a junk shop situated in a slum part of London.

The 'journalist' strain in Frith, his sense of what was topical, and, as Flatow would have said 'make the pictur' go', informs his choice of subject here, even if only unconsciously. The series was done at a time when the newspapers were full of tales of gambling in high society and when the revelations of the Baccarat Scandal, involving the heir to the throne, supplied a constant supply of ready-made themes and texts for sermons and leading articles.

Not everyone was impressed, though, by Frith's penny-a-line moralizing, and one critic even speaks of his 'ill-advised attempts to rival Hogarth', whilst an outraged leader-writer did point out that if we were to reprimand every public man who had played cards at college there would be no one left to run the country and most of the bishops' palaces throughout the land would be bereft of their Fathers-in-God.

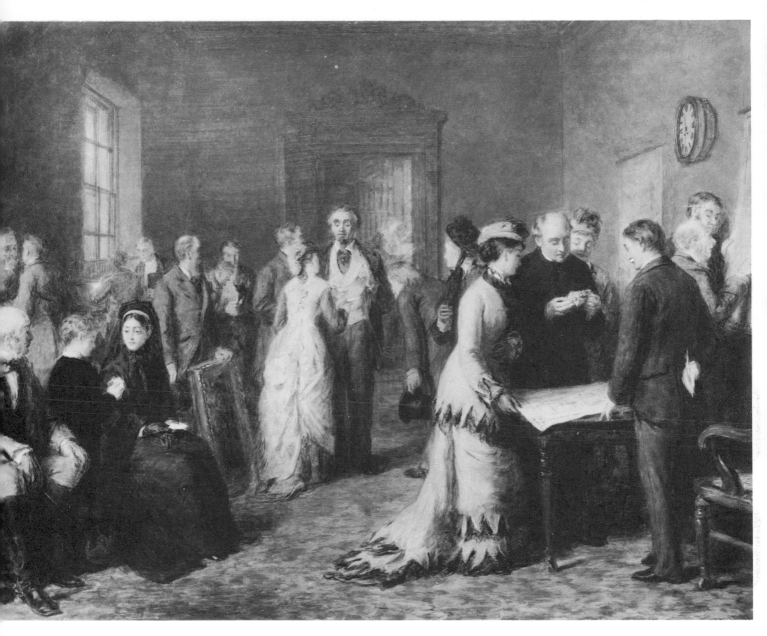

The Spider at Home.

1880. 12 x 15½ ins. Courtesy of Thos. Agnew & Sons, London.

This is a preliminary sketch on board for the second painting in the series of five entitled *The Race for Wealth* (c/f *The Road to Ruin,* 1878). The original series is now in the Baroda Museum, India.

However, as we have mentioned earlier, Frith never bothered with critics, and obviously few of his admirers paid much attention to them either, since, encouraged by the success of *The Road to Ruin* Frith immediately embarked on a new venture: another series of five pictures representing, this time, the career of a fraudulent financier, or promoter of bubble companies. He probably had in mind the strange career of Baron Albert Grant, a notorious company promoter who crashed sensationally in the late eighteen-seventies; he went bankrupt for £20,000,000. Another likely source of inspiration was his friend, Anthony Trollope's novel, *The Way We Live Now* (1875), which 'Cissy' probably read aloud to her father. This is the novel, which was turned into a successful television play a while back, and in which is outlined the career of Auguste Melmotte.

Signed and dated 1880, and like *The Road to Ruin*, a series of five paintings measuring 28 × 36 inches, *The Race for Wealth*, is now in the Baroda Museum, India. The running order of the picture-titles is: (1) *The Spider and the Flies*; (2) *The Spider at Home*; (3) *Victims*; (4) *Judgment*; (5) *Retribution*.

Frith's first scene is set in a financier's office where the principal 'flies' are seen to be a clergyman, with his wife and daughters. They are examining samples of ore, alleged to be the product of a mine containing untold wealth. A map of the mine, full of such promise, dangles seductively on the wall. The office is crammed with sundry other gullible and potential runners in the race for wealth: a pretty widow with her young son; a rough country gentleman complete with overcoat and riding-boots; a foreigner, bowing and scraping to the great projector as he sails into the room from an inner office in which clerks are seen industriously scribbling away. A picture-dealer is obviously hoping to sell the financier 'a gem', and various other 'flies' help populate Frith's painting and buzz round the carefully-spun web.

In the second painting the 'Spider' is seen entertaining guests in his handsome drawing-room. Frith has depicted him in evening dress, extolling the merits of a large picture to a group of the guests, 'one of whom, a pretty girl, shows by her smothered laugh that she appreciates the vulgar ignorance of the connoisseur, whose art terms are evidently ludicrously misapplied'. The double drawing-rooms contain many figures, some of whom Frith intended should be recognized as the clients in the first scene at the office. Others are fashionables with an eye to the main chance, whose dog-eyed worship of success, combined with the hope of being able to help themselves to a sizeable slice of it, so often betrays them in keeping strange company.

In the third of the series the crash has come, and the scene is thus described by Frith: 'The foolish clergyman sits at his breakfast-table, with his head bent to the

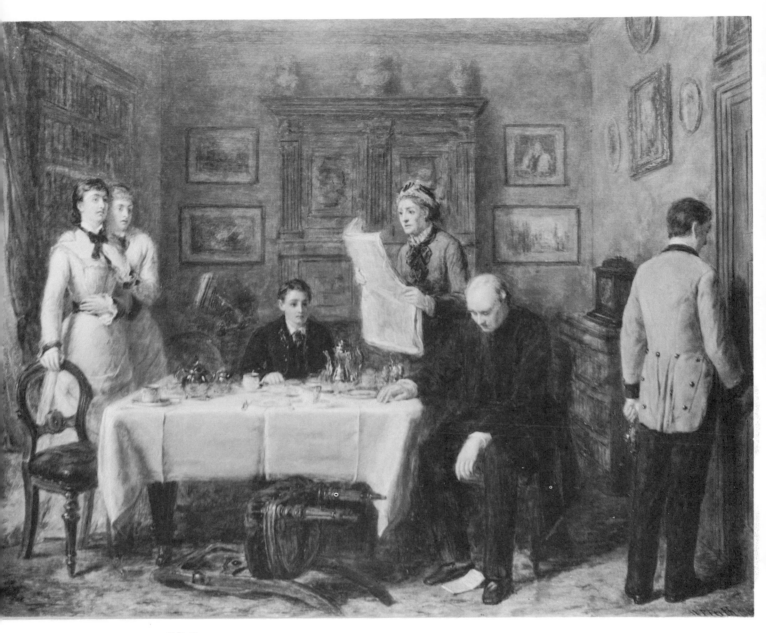

Victims.

1880. 12 x 15½ ins. Courtesy of Thos. Agnew & Sons, London.

The preliminary sketch for the third painting in the *Race for Wealth* series.

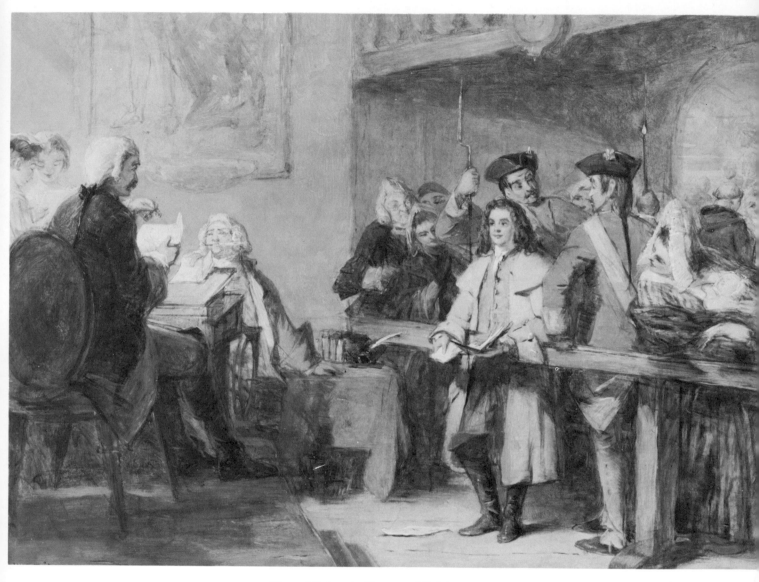

Hogarth Before the Governor of Calais.

1856. 12 x 16 ins. Courtesy of Roy Miles Fine Paintings, London.

This picture shows the artist William Hogarth being brought before the Governor of Calais after being arrested as a spy in the act of sketching the 'Gate at Calais' for the background of his famous picture of that name. Had peace not been signed between France and England a few days previously he would most certainly have been hanged on the ramparts.

blow. His wife, with terrified face, reads the confirmation of her worst fears in the newspaper, which a retreating footman has brought. Two daughters have risen terror-stricken from their chairs, and a little midshipman son looks at the scene with a puzzled expression, in which fear predominates. The catastrophe is complete: the little fortune has been invested in the mine, and the whole of it lost. But my hero has been overbold; he has produced ore, which his impending trial proves to be the product of a mine, but not of the one in which his unhappy victims took shares. He is arrested, and takes his place in the dock at the Old Bailey, where we must now follow him, and also arrive at the fourth of the scenes . . .

'See the financier there standing with blanched face listening to the evidence given by the clergyman, which, if proved, will consign him to penal servitude. His victims – recognizable as those in his office in the opening of my story – stand ready to add their testimony. The widow, the foreigner, the country gentleman, are there; and so also are some of his aristocratic guests, one of whom studies his miserable face by the aid of an opera-glass. The counsel and the jury examine the real and the spurious specimens of ore. The evidence is overwhelming, the verdict is pronounced; and that it is "Guilty" is proved by the final scene, where in prison-garb the luckless adventurer takes his dismal exercise with his fellow-convicts in the great quadrangle of Millbank Gaol. And so ends my tale . . .'

With his customary zeal for authenticity Frith visited several City offices – stockbrokers' and others, but, understandably, found none of his business friends keen on the idea of having their premises used as the setting for the activities of a crooked financier! So, perforce, he had to use his own drawing-room as the reception-room for his hero's company: 'and the Old Bailey, being common property, I found no difficulty in taking measurements and photographs of that dreadful place. I examined every part of it. I made my way from Newgate through subterranean passages to the dock, in which I took my place as an imaginary criminal. I tried to realise the impression that the sight of the judge, with the sword of justice over him, together with a crowded court, would produce on the half-dazed eyes of the poor wretch who had come upon the scene through those dim passages. I hear of an intention to pull down the old court, which is, no doubt, in many respects inconvenient. If that should happen, my trial-scene will acquire an additional interest; for, well or ill-done, it is an exact representation of the Old Bailey.'

Most interesting, this; and it does highlight one aspect of Frith which several critics have commented upon: the fact that there is not really all that much difference between Frith's contemporary scenes, the consciously historical paintings, and those everlasting reconstructions of his scenes from Sterne and Goldsmith. In all cases his approach was that of the historical painter; the thorough research,

[125]

the hunting-out of old furniture from junk shops, the detailed building-up of architectural details, often using photographs, and, in general, an exemplary display of that industry the Victorians never stopped chattering about. People who got worn out changing their clothes for meals and varying times of the day spoke endlessly, and with conviction, on the immense moral value of work – for others, for their servants, for the factory hands who created the great wealth which underwrote their own tom-fool assaults upon Society.

As they say of those tiresomely over-researched contributions to 'Eng. Litt.' ('doubtless the author had in mind that memorable passage from Xenophon' where the authors seem more intent on impressing us with their irrelevant, rag-bag of erudite but useless information, than on enlightening us usefully on the matter in hand, their works smell of the midnight oil. Thus, although he makes much of his industry in his *Autobiography* it is an open question if much of it was, on balance, all that wise. In a sense Frith adapted the methods of the historical painters, who were so highly esteemed in his student-days, to the requirements of contemporary painting. As a result of this, Christopher Wood feels, 'his big pictures have a curiously static, immobile appearance, as if all the figures were suddenly frozen into an immense tableau. They are better examined in detail.' Sacheverell Sitwell, too, in his classic work on *Narrative Pictures* felt that *Derby Day* was a panorama upon an immense scale rather than a work of art.

The series, *The Race for Wealth* was exhibited in King Street, St. James's, and attracted a great deal of attention. The pictures were translated by photogravure, 'but whether from the faults of the pictures, or of the method in which they were reproduced', writes Frith, 'the result was far from satisfactory'. Frith does not elaborate on this point in his *Autobiography*, but it needs to be remembered always that, in his heyday, much of Frith's popularity (and income) was governed by the high value of his steel-engraving rights, and that these fell with the advances in the late nineteenth century of photographic processes, not all of which struck Frith, obviously, as all that good from an artist's standpoint.

As Gerald Reitlinger points out, in 1896, when Frith was still working a little at the age of seventy-five, the sudden collapse in the value of his paintings was as dramatic as it had been at any time in the present century: 'His case was therefore unique among the most high-priced mid-Victorians, such as Millais, Alma-Tadema, Burne-Jones and Lord Leighton, none of whom lived to see the decline of their market.'

CHAPTER TEN

John Leech: His Life and Work by W. P. Frith

ANTHONY TROLLOPE DECLARED that the popularity of *Punch* was 'owing, per-
haps, more to Leech, its artist, than to any other single person'. Maybe, so, but
Leech also contributed to a mass of other periodicals, including the early numbers
of *The Field* which contain many felicitous hunting and racing sketches by him.
That once-familiar compilation, Blaine's *Encyclopaedia of Rural Sports* also has
buried away amidst its double-columned pages a litter of Leech sketches. He also
illustrated many of those Victorian novels which have become since Michael
Sadleir's time somewhat expensive collectors' items, viz.: Albert Smith's *The
Physiology of Evening Parties* (1840); and *The Marchioness of Brinvilliers* (1845);
Douglas Jerrold's *A Man Made of Money*, and many more.

These awful confections remain largely unread today and we suspect that if
they are looked into at all it will be for the Leech plates, and his pleasing yet
unpretentious illustrations in text. Yet it is largely from these frightful works
that Frith decants huge chunks of direct quotations into his text, either that, or
leisurely synopses of the plots of such novels in order simply to explain a dozen
or so sketches by Leech in his most unsatisfactory rag-bag of a book, *John Leech:
His Life and Work*, 2 vols. (Richard Bentley, 1891).

'If Leech, artistically, was not at his best in the Surtees novels, then he had,
artistically, no best at all', the Rev. Gordon Tidy writes in his *A Little About
Leech* (Constable, 1931). 'To pass from the stilts and struts of – to give one in-
stance – the illustrations of *The Marchioness of Brinvilliers* to the life and movement
of "Jorrocks" is to leave the galleries of Madame Tussaud for the life and move-
ment of the men and women in the street. For Theodore Hook, for Douglas
Jerrold, for Albert Smith, and for Charles Whitehead, Leech made his black
etchings, and growling and grumbling, sent them to their destinations. But for
Surtees he put on his red coat and rode gaily to the meet.'

And, since the Leech-illustrated novels of Surtees are so often to be seen,
either in the gold and scarlet of their original bindings in country-house libraries,

or in later reprints of varying sumptuousness, it might be expected that Frith would have something of value to tell us about them – but no. He refers to 'some sporting novels, written, I think, by a Mr Surtees . . . As these works are ornamented by coloured steel engravings and innumerable woodcuts by Leech, it has been my duty to look into them; read them, I cannot. I hope if the author is still living [R. S. Surtees died in 1864] he will attribute my want of appreciation to a want of sympathy with his heroes and heroines, though I admit, in the portion I have read, that he shows considerable humour as well as power in expressing it. This, from one who knows his own ignorance of the subject in question, should be gratifying to Mr Surtees.'

With friends at court like that who needs . . . However, let us now contemplate the fate of poor Leech. Dickens had his John Forster . . . and since his biography appeared the making of books on Dickens has had no end. But, Leech? Everyone agreed, absolutely, that he was the-greatest-chap-that-ever-was; the kindest, wittiest, most lovable man; so generous; loved children, and was even singular enough to love his wife and feel that there was no place like home. Stories about him! Why, bless you, sir!

That was all very fine, but the trouble was that everybody who said he was going to write a book about the admirable man seemed to get stricken with arthritis of the wrist before he reached the second or third page of his manuscript. Dr John Brown, author of that once-celebrated work, *Rab and His Friends*, was going to write his life, and, indeed, did get as far as producing an article on Leech in the *North British Review* (1865), illustrated by eight reproductions of Leech's work, in which he alludes to his 'projected memoir'. When Dr Brown died in 1882 the world still awaited this 'projected memoir'. Then, S. Reynolds Hole, the Dean of Rochester, and a personal friend of the artist's for six years, burrowed away in the British Museum Library among the many fugitive publications to which the industrious Leech contributed; he met the artist's widow and various other members of his family; sorted out and numbered countless letters; and then went off to dine with Leech's old hunting companion, Charles F. Adams of Barkway, Hertfordshire, who regaled him with stories of lively evenings around his table when Leech, Millais, Tenniel, and Mark Lemon, the editor of *Punch* had been his guests at his large red brick house in the heart of the Puckeridge country, with its ivy, gables and twisted chimneys. Soon, the Dean's family got used to hear him chattering away about 'my book'; about Adams: 'He is going to send me all his correspondence, sketches, etc.' But, in the midst of his flurry of activity, the Dean heard about Dr John Brown's 'projected memoir' and bustled away to Edinburgh to talk to him about it.

What happened we do not precisely know beyond the fact that Dr Brown kept talking about that 'projected memoir' of his, and Hole supplied him with material

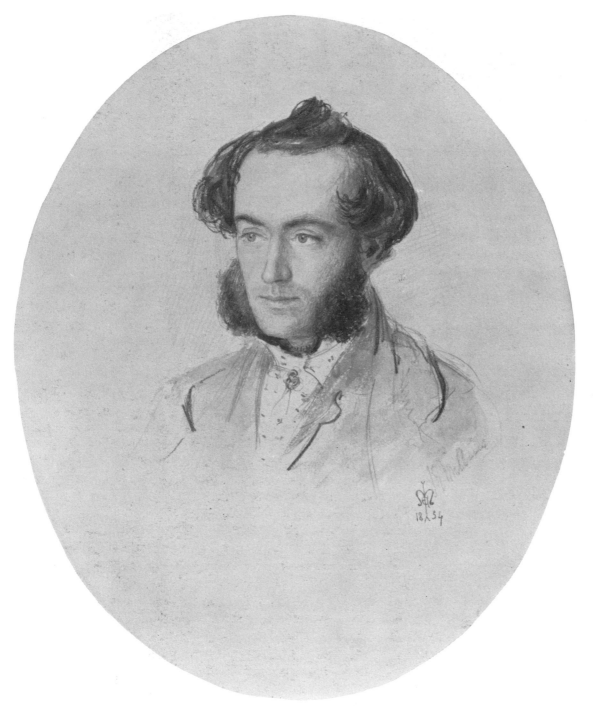

John Leech.

1854. 13⅜ x 10 ins. Courtesy of the National Portrait
Gallery, London.

for it which Dr Brown incorporated into an essay which later appeared in *John Leech and Other Papers*. The outcome was most unfortunate since neither man got around to producing the desired full-length study of Leech. Moreover, as time went by, the people who had known Leech kept dying off, naturally.

The Dean himself read the burial service over Leech at Kensal Green only a short time after he had performed the same melancholy duty for their mutual friend, Thackeray. The novelist and Leech had known one another since Charterhouse days. Hole writes:

'I said the Burial Office as best I could at the grave, which was close to Thackeray's, and which was surrounded by his friends. The pall-bearers were the four consecutive editors of *Punch* (Mark Lemon, Shirley Brooks, Tom Taylor, and Francis Burnand) Millais, Tenniel, Lucas, Mayhew, Silver and Evans. Dickens and many other distinguished men were mourners. Looking up during the service, I was for a second startled to see what seemed to me at first an apparition, an exact likeness of what John Leech would have been had he lived to old age. It was his father, whom I had not met before.'

Maybe, as they all stood there around the graveside the Dean recalled the fortnight's holiday he had spent in Ireland with Leech, the outcome of which had been *A Little Tour of Ireland* by him, with the illustrations by Leech; when they had looked over the Bay of Dublin from the hill of Killiney, 'wandered among the solemn mountains and lakes of Connemara, all but danced with joy over the first salmon which he caught at Kylemore, shot the weir between the upper and lower lake at Killarney, rowed by moonlight to Innisfallen, talking to the boatman about the O'Donoghue, and listening to the bugles as they set the echoes flying, travelling mile after mile of tranquil enjoyment in the cosy Irish car . . . memories to make an old man young. He was perfectly successful in all his attempts at delineation but one – the portrait of a most offensive odour in Cork Harbour, which, he said, taking out his book and pencil, "was quite strong enough to sketch". He had previously achieved a representation of a sneeze, which is still in my possession.'

Such stray recollections of Leech, embedded in the odd chapters devoted to him in *The Memories of Dean Hole* are, alas, all we have of what might have happily flowered into an agreeable Victorian memoir of Leech, composed in the Dean's leisurely and cultivated style – embellished here and there with those felicitous quotations from Sallust, Cicero, or Wordsworth he loved so much, and which would have imparted to it a fragrance as delicious as that of the roses the Dean cultivated so expertly.

Rumours of other biographies of Leech in progress surfaced from time to time in the literary world, but nothing much happened. True, F. G. Kitton produced a brief work on him in 1883 which won praise, and a new, revised edition came out

in the following year, but the portrait of Leech and some of the illustrations which had been in the earlier one disappeared from it. Then, seven years later came Frith's two-volume effort.

It really is a frightful mess from which no clear picture of Leech emerges at all, and is useful only as a quarry to later writers. There is a maddening shortage of dates and no very clear arrangement of subject-matter. It is all very sad since Frith knew Leech well and clearly appreciated his work. As the Rev. Gordon Tidy puts it, (and, we feel, it is the last word to be said usefully on the subject of Frith's *John Leech*):

'That it required the printing of 879 lines of quoted verse to explain twelve of Leech's illustrations, and those illustrations, with one exception, not of much importance, is by no means certain. Nor is it by any means certain that more than 150 pages of either quoting from or analysing forgotten books illustrated by Leech were necessary, especially as the best that can be said for the books referred to is that they had Leech for their illustrator. Such quotations and analysis may be pertinent, but they run a great risk of being mistaken for padding . . . The book, too, has no Index. That is a pity, because from a good index a reader might make a catena of passages critical of Leech's art, and Frith was far better qualified for criticising Leech's drawing than, as it seems, he was for writing his life.'

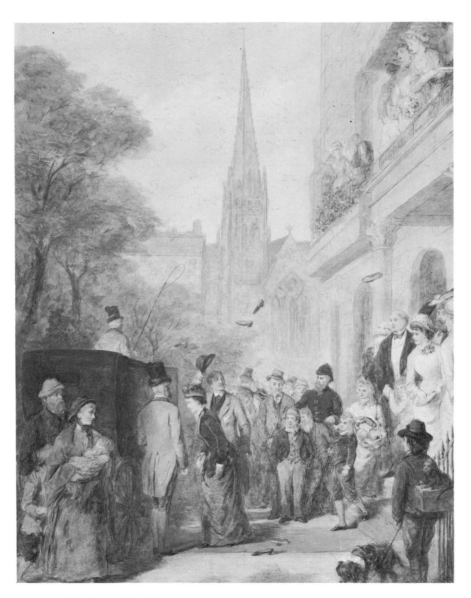

For Better, For Worse.

1881. 24 x 18½ ins. Courtesy of M. Newman Ltd., London.

This is a smaller version of the painting exhibited at the R.A. in 1881 and at St. Jude's Gallery in 1885. It was recently featured in the '19th Century Life' exhibition at M. Newman Ltd., London (1965).

CHAPTER ELEVEN

Frith Liked Crowds

WHEN FRITH MARRIED ISABELLE, the daughter of George Baker of York, on 22 June 1845, his mother made him an allowance of £150 a year and they began their married life in rooms at 31, Charlotte Street, Fitzroy Square, but by the time 'Cissy' (Mrs J. E. Panton) was born they had moved to 13, Park Village West, Regent's Park, and it was from this address that Frith submitted his Royal Academy offerings from 1848 to 1852. His submissions from *Ramsgate Sands* (1854) round to 1888, though, were made from the address we most readily associate with Frith in his heyday: 16, Pembridge Villas, Bayswater. It was there that Queen Victoria came to see him and view *The Marriage of the Prince of Wales* (1865). Briefly, from 1889 and 1896 he got lost in South London: Ashenhurst, Sydenham Hill, before spending the evening of his life at 114, Clifton Hill, St John's Wood, where, the observant wanderer will spot blue plaques by the score reminding us how much this area was in fashion at the turn of the century amongst successful artists.

As 'Cissy' writes: 'Artists in our day were divided into sets, much more I fancy, than they are now. There was our set, centred in the Kensington and Bayswater districts; there was the St John's Wood set; and there was another set which comprised Millais, Leighton, Sir Frank Grant, and some of the more aristocratic members of the Academy.'

The trouble with so many painters, writers discover, disconcertingly enough, is that many of them have been basically 'loners', toiling away quietly for years in search of that impossible dream at the end of the rainbow that haunts them day and night, year in year out; their private life is something that just happens, and we suspect, is not all that important to them, so that their work aside, the material for the rest of their life can often be encapsulated in a mere dozen or so pages. But in Frith's case we are singularly fortunate: we have his *Autobiography and Reminiscences* (three large, fat, rambling volumes); he kept diaries; corresponded with Dickens, and other notable people; and, after his mother's death, wrote

[133]

enchanting letters to a favourite sister; but an even richer bonus for us are the sidelights and impressions thrown upon life in the Frith household supplied by 'Cissy' in two autobiographical works: *Leaves from a Life* (1908), and *More Leaves From a Life* (1911), published under her married name, Mrs James Panton.

Mrs Panton (1848–1923) married James Panton of Wareham, Dorset in 1869 and had three sons and two daughters. She wrote a stream of novels, as did her brother, William, and features in women's magazines on interior decoration and kindred subjects, but it is above all for her reminiscences we cherish her, and feel that the intimate view she gives us of life in the household of a successful Victorian painter deserve something better than the near-oblivion of books long out of print and difficult to obtain.

'Ours was never a silent household', she writes; 'and we one and all of us read every book and paper we could lay our hands on; first of all to talk over things with Papa, and afterwards because we loved reading for its sake.' As she grew up she found herself more and more pressed into service as a model, not only for her father but for his friends, too. 'The subjects of more than one picture for which, as a child and young girl, I acted as artist's model were absolutely incomprehensible to me, notably a picture of Mr Egg's, where I am one of the children building card houses, while the mother is being tempted from the home by a man who is bending over her on the sofa. The picture is called *The Gambler's Wife*, and it is especially impressed on my mind because the attitude I had to assume is a kneeling one, and I fainted for almost the only time in my life; and I have never forgotten the sudden oblivion that preceded my fall from the "throne" (the round green pedestal table on which all sitters used to be placed, and I daresay are now), and my coming to in the kitchen, with kind Susan bathing my head, regardless of the fact that soapy water was meandering down the front of my best frock.'

Never a silent household? Jane Ellen Panton could have said *that* again! Not content with twelve children in normal wedlock – five sons and five daughters survived Frith at the time of his death in 1909 – he ran a mistress in Oxford Terrace (now Sussex Gardens) named Mary Alford and had two children by her, Agnes and William Powell, before his first wife's death in 1880. After a respectful period of mourning (one year, two days) he married Mary Alford at Paddington and had another four boys and a girl by her. So, in the two families, Frith had nineteen children. As Jeremy Maas dryly observes: Frith liked crowds.

Isabelle's suspicions about her husband's double life were aroused after her husband had been away a few days, and, quite by chance, she spotted him posting a letter near their Pembridge Villas home. It told her he was having a nice time in Brighton! Another personal note, which is not without interest as we study *For Better; For Worse* (1881) is that Frith was inspired to paint it when he saw an

almost identical realization of it in Cleveland Square. The house has not been precisely identified, but the church is based on Christ Church, Lancaster Square, Bayswater. The couple are leaving for their honeymoon amidst the customary shower of slippers and rice, and it was completed at the time of his own irregular second marriage.

Thus, it can well be imagined from these notes that the arrival of a fresh baby in the Frith household lost something of the novelty it possesses in most families, and so her following observations about their childhood outings in Kensington Gardens inform in a far more meaningful way than Mrs Panton's original readers ever suspected: 'myself and my sister clad in Rob Roy plaid pelisses, shoes and white socks, and brown bonnets, with caps with tiny pink rose buds, inset all round the face, and tied tightly under the chin, and our hands in thread gloves; while Willie, dressed in a belted tunic and white drawers and a hideous tasselled cap on his head, walked a little disdainfully in front; then came the nursemaid with what we called the "push-along"; the word perambulator had not then been heard: bearing a couple of smaller children, while the old Nurse staggered after us bearing "the long-clothes", the name of derision we always gave to the latest arrival.

'The "long-clothes", when we wore the Rob Roy pelisses, was born in 1853, and was the first to arrive on the scene in Pembridge Villas, and for some reason or other she was always outside the inner ring of our games, and finally, when she was ousted from the position of youngest by two or three more "long-clothes", who arrived one after the other far too fast to please us, for we were frightfully tired of babies by this time, we made her and ourselves believe she had only been an adopted baby . . .'

However, as a seasoned professional model of nine, 'Cissy' fools us all as to her rebel views on babies in Henry O'Neill's *Eastwood Ho!* (1857), that classic painting chosen by the Arts Council to decorate the cover of their Great Victorian Pictures catalogue of the Burlington House exhibition (1978), in which she can be seen making a fuss of baby.

We catch glimpses of 'Papa, coming in for five minutes with a biscuit in one hand and a glass of sherry in the other (his usual luncheon), leaving the model to consume her lunch, while he told us stories of his morning's work and heard in return all the latest news from the schoolroom and the rapidly filling nurseries overhead.' One pet game in the nursery was from Defoe's *The Plague of London*: 'the dolls' house was marked with a red cross; while the dinner-bell was tolled by Willie, and we duly brought out our dolls "dead" and thoroughly enjoyed the gruesome entertainment'.

Mrs Panton claims that her father owed much to her mother's taste and hints as regards colours and draperies used in his pictures, and also that she was a

[135]

The Sick Doll.

1885. 28 x 36 ins. Courtesy of M. Newman Ltd., London.

quietly determined woman. For example, she upset her grandmother when she told her she would have none of 'the bridesmaid came too' nonsense on *her* honeymoon, as was customary in the early nineteenth century: 'Mama declined both cap and front and set her face against the almost universal travelling bridesmaid.' Mrs Panton also shudders at the memory of 'the fearsome manner in which the house (at Pembridge Villas) was decorated . . . in the dining-room was a heavy dark red flock paper and grained paint, which put on when we entered the house remained as it was until about 1870, when it was redone after my mother's own taste, and was made artistic and beautiful'.

On Sundays at Pembridge Villas, Frith delighted in visiting the painting-rooms of fellow-artists living in the area: Augustus Egg, Mulready, Thomas Creswick, Henry O'Neill, Ansdell, and others: 'in the afternoon we generally got him to go out with us, and in the evening we had delightful gatherings'. She vividly recalls seeing the Duke of Wellington when she was out driving in a cab with her mother: 'he was very bent, and his head seemed sunken on his chest, and every now and then he raised a couple of fingers to his hat as he was saluted by the crowd, and quite well do I remember his long, thin legs in white trousers tightly strapped beneath his boots, and the stolid groom following behind'. She also recalls being taken to see the Duke's funeral car when it was housed in the stables of Marlborough House, before its removal to the crypt of St Paul's Cathedral.

Like most Victorian parents Mrs Frith was a great one for dosing her children: 'Every year in the early spring she made a jorum of treacle and brimstone, which she kept on the washing-stand shelf in Papa's dressing-room, a wooden spoon in it coming through a hole in the paper cover and for about a fortnight she enacted the part of Mrs Squeers on her unfortunate offspring. But at last, the evil having entered us, we incited Willie to eat the lot at one sitting, and the result was so disastrous that she gave up the brimstone and treacle regime from that day. Then there was an awful dose the nurses called "sinner and pruines" (senna and prunes), which was brought hot and odiferous at dawn to the unhappy invalid. Rhubarb and magnesia had been tried, but as we invariably rose, smashed the cup, and sprinkled the bed and bearer, it was given up, and our worse dose was hot castor oil and milk, shaken together in a bottle and poured from the bottle down our throats.

'A strong peppermint lozenge somewhat mitigated our woes, while those who had not been dosed incited the invalid to dance so that the hideous liquid might be heard to wobble about inside the victim, which shows what imagination will do! Then we had powders, but these the doctors brought; Mama did not make these. It fell to her and Miss Wright [the governess] to conceal them in different vehicles, hoping to take us in and cause us to take them in their turn. But we always found out in time to avoid the gritty deposit, and at one time the two

Child Study.

1857. 11 x 19 ins. Courtesy of The Leger Galleries, London.

A crayon drawing heightened with white.

busts which stood half-way up the stairs on red pedestals were full of figs which we concealed there, and were never discovered, as far as we knew; or if, our dear friend, the housemaid, found them she at all events never told on us, but simply burnt them.'

In October Mrs Frith brought out her small and precious saucepan, 'and over a fire lighted specially in her bedroom – fires were never allowed upstairs except in cases of real and severe illness – she would concoct camphor balls for chapped hands, which we were allowed to roll up in silver paper to preserve them for use, and a salve for the lips made from wax and a sweetly-scented *rose* essence, which we fetched from the chemist's shop in Oxford Street, kept by our beloved patron, Jacob Bell, where our still dearer friend, Mr Hyde Hills, was always to be found in a species of glass-room beyond the inner shop, from whence he used to emerge to kiss us and fill our hands with delicious acid-drops and pear-drops, which lived in glass jars all along a shelf behind the long counter. How good the men of those days used to be to little girls!'

Mrs Panton speaks of the London of her childhood being peopled by characters straight out of Dickens and Thackeray, and assures us that if we wish to catch the authentic flavour of the 1860s and 1870s we should read the novels of Trollope: 'especially read those illustrated by Millais and Freddy Walker. You see the people and feel the atmosphere and know just exactly what they did and saw and heard.' She recalls reading *Silas Marner* aloud to her father, and many more novels. But the really frequent visitors to the Frith household in the way of literary lions were the *Punch* crew, and especially Shirley Brooks, its one-time editor ('Cissy' was a great pet of his), and John Leech, before his much-lamented early death. It was Shirley Brooks who perpetrated the following jingle about Frith:

> I ups and paints, hears no complaints,
> And sells before I'm dry,
> Till savage Ruskin sticks his tusk in,
> And all is up with I.

When Robert Browning asked Frith if his son, Pen, should take up painting or sculpture, the 'auctioneer' side governed Frith's choice: painting; less expensive.

These fascinating sidelights on life in the Frith household drawn from Mrs Panton's neglected books have been quite a 'find' to us and we hope they delight many others; but, since she writes of her father's 'unfortunate' second marriage, we suspect that a note of estrangement crept into their relations and her firm information (as apart from hearsay) about her father's later career becomes thinner and less reliable.

Towards the close of the year crowned with the purchase of *Ramsgate Sands* by Queen Victoria, Frith prepared a sketch for the birthday painting we know as *Many Happy Returns of the Day* (1856). The scene is set at Pembridge Villas which Mrs Panton describes so vividly, and the little girl whose birthday is being celebrated is the painter's daughter, Alice. He himself appears in the painting as the complacent paterfamilias, wine-glass casually in hand as the toast is being offered to the child, whilst his mother on the left-hand side plays her real-life part of grandmother. Frith writes: 'The heroine sits in a high chair, which has been decorated for the occasion with a wreath of flowers, and is somewhat bewildered by her uproarious brothers and sisters, whose wishes for many happy returns of the day are screamed by half-a-dozen shrill voices. The parent pair preside, of course, assisted by friends; whilst the grandfather and grandmother look sympathetically on.' The grandfather in the picture was 'a man who had seen better days, and found refuge in the workhouse for his old age'. The painting, engraved by Lumb Stocke, proved very popular. When it went on show at the Royal Academy Ruskin 'stuck his tusk in' and contributed some of his characteristic moral twaddle in his 'Academy Notes, 1856': 'A taking picture, much, it seems to me, above Mr Frith's former standard. Note the advancing pre-Raphaelitism in the wreath of leaves round the child's head. One is only sorry to see any fair little child having too many and too kind friends, and in so great danger of being toasted, toyed and wreathed into selfishness and misery.'

The condescending pat on the head did nothing to assuage Frith's response: 'Ruskin's works bristle with errors; one of his notable ones was his saying, on the discovery of what he took for pre-Raphaelite work in one of the worst pictures I ever painted, that I was "at last in the right way", or words to that effect.'

How often Frith and Dickens seem to complement one another: the Tuggs's at Ramsgate seem to have crept into *Ramsgate Sands*, together with the Punch and Judy show, the menagerie, the minstrels, the portable chairs, the ladies knitting or reading, and even the old boy with the telescope. So, with the birthday picture. To add flavour to your enjoyment of your framed engraving of it by Lumb Stocke sample Dickens's *The Uncommercial Traveller*, (XIX: Birthday Celebrations), where the 'Uncommercial' recalls being taken out 'to visit some peach-faced creature in a blue sash, and shoes to correspond, whose life I supposed to consist entirely of birthdays. Upon seed-cake, sweet wine, and shining presents, that glorified young person seemed to me to be exclusively reared.'

CHAPTER TWELVE

Dickens and Frith

AS MIGHT BE GUESSED FROM THE 'theatrical' quality of much of Frith's work he was an assiduous theatre-goer and friend of many notable actors and actresses, about whom, like so many other Victorian worthies, he has stories to tell in his *Autobiography*. It was typical that before being consigned to the care of Henry Sass he went to see a 'a kind of lecture' at the Adelaide Gallery, where a steam gun discharged a hundred bullets a minute and the speaker informed his audience that the Duke of Wellington had been to see it 'the day before yesterday', and that if the Duke had had the benefit of 'that 'ere steam-gun' the Battle of Waterloo would have been over in about half-an-hour instead of lasting all day. He also celebrated with his father by going to see Macready in Shakespeare's *King John*.

Years later he 'assisted, as the French say' at the Macready banquet when the veteran actor retired from the stage, when Bulwer Lytton took the chair and Dickens stage-managed the whole affair. In a letter to his mother (March 1851) he ruefully described how his dinner cost him a guinea and a headache, 'besides a fight, or nearly one, for my hat and coat. Just fancy six hundred people all struggling at the same time at a small table to get their hats and go away. The waiters were all drunk, and that happy condition was no assistance to them in their efforts to distribute the hats to their owners; indeed, to judge from the maudlin way they tumbled and reeled about, one might fancy that they had been shipwrecked on a sea of hats and coats, and were in despair of ever reaching dry land.'

Gambart introduced him to Sarah Bernhardt in Paris and together they visited her in her sumptuous, over-furnished home: 'as we entered, a boy dressed in white, with yellow hair, sprang from a sofa and greeted us warmly. The seeming boy was Miss Sarah Bernhardt, whose masculine attire was assumed for the convenience it afforded for the practice of the art she loves far more than that in which she is so famous. She made the astounding declaration to me that she hated acting; and would rather succeed in painting or sculpture, or in both, than in any other earthly calling.'

Irving; J. L. Toole; Ellen Terry; Fetcher, who was a frequent guest at Pembridge Villas; and many other players less well known to us now flit through Frith's pages, whilst his daughter, 'Cissy' writes: 'We must have been taken to many a play – but my first real remembrance of the theatre dates from the year 1860, when the Boucicaults burst upon London, and we were thrilled night after night by *The Colleen Bawn*. I do not know how many times I saw that play, but as we knew the Boucicaults, who were extremely good to us, we could always have a box, and were it necessary I could, I am sure, stage-manage the play from beginning to end.'

As a frequent guest Frith saw Dickens play the principal part in Wilkie Collins's *The Frozen Deep* and other amateur productions in his Tavistock House Theatre and elsewhere and even had the temerity to advise him about his 'reading' of the part of Sam Weller when Dickens turned public reader. These readings from all accounts, were much more like the solo readings as Emlyn Williams has given them to us than mere author's readings: real, theatrical *tours de force*, which galvanized his audiences, and doubtless wore him down in the end.

Frith heard him read the trial from *Pickwick* at the Hanover Square Rooms when Dickens commenced his readings, but 'felt very strongly that the author had totally misconceived the true character of one of his own creations. In reading the humorous repartees and quaint sayings of Sam Weller, Dickens lowered his voice to the tones of one who was rather ashamed of what he was saying, and afraid of being reproved for the freedom of his utterances. I failed in being able to reconcile myself to such a rendering of a character that of all others seemed to me to call for an exactly opposite treatment. Sam is self-possessed, quick, and never-failing in his illustrations and rejoinders, even to the point of impudence.'

Finding Dickens in a good mood he unburdened his mind on the subject, as Dickens listened, smiled faintly, and said not a word; but a few days later Alfred Elmore asked his opinion of the readings since he was going to hear them, and Frith warned him that, frankly, he would be disappointed with the character of Sam Weller. Elmore, meeting him after he had been, roundly abused him for giving him so false an account: 'Why, the sayings came from Dickens like pistol-shots; there was no "sneaking" way of talking, as you described it.' When he met Dickens later and enquired what had happened, Dickens replied: 'I altered it a little – made it smarter', adding, 'whenever I am wrong I am obliged to anyone who will tell me of it; but up to the present I have never been wrong.'

So their friendship burgeoned, with invitations to the various homes of the novelist, including Gads Hill. A diary entry of Frith's for December 1858 reads: 'The day was wet and dreary, but we passed it agreeably in talk and bagatelle; the players being Wilkie Collins and myself, with Dickens and Gordon – most genial of Scotsmen and Sheriff of Midlothian – for opponents.'

[142]

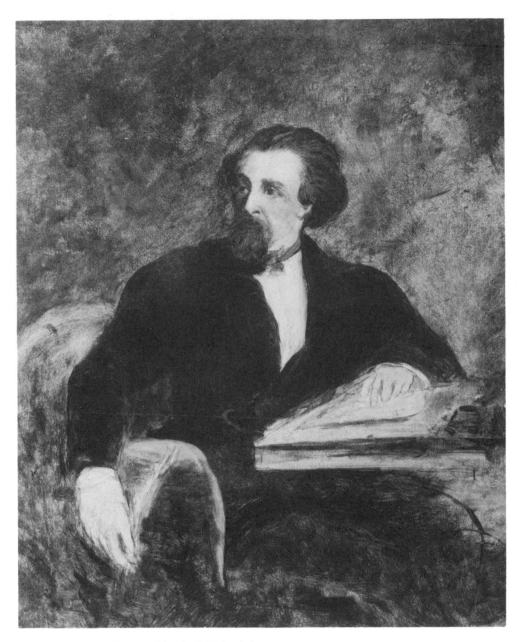

Portrait Sketch of Dickens.

On a panel. 14 x 11¼ ins. Courtesy of Thos. Agnew & Sons, London.

Frith's association with Dickens sprang out of his first Dolly Varden painting and commissions from the author in 1842. He survived the novelist (who died in 1870) by nearly forty years and became one of the oldest living links with him until his own death in 1909. This is the sketch for the familiar portrait of Dickens in his study at Tavistock House painted in 1859 and now in the Victoria and Albert Museum, London. See Plate Six.

On another occasion he recalls seeing Dickens, and finding him surrounded by that flattering but sometimes embarrassing tribute to genius: a stack of unsolicited manuscripts from humble disciples begging for the great man's opinion. 'Seems clever – a good style; suppose I must read it,' said Dickens, taking up one from the pile; and read it he did, for the very next day he remarked to Frith: 'That's a very good book, indeed, by George Eliot. But unless I am mistaken, G. Eliot is a woman.' The novel was *Adam Bede*.

What we will not find in Frith's *Autobiography*, however, but which we do in Mrs Panton's *Leaves from a Life* is an invaluable sidelight on the controversy which raged in literary and artistic circles over the break-up of Dickens's marriage. She writes: 'I well recollect being in a box at the theatre one evening with my mother and Mrs Dickens: the latter burst into tears suddenly and went back into the box. Charles Dickens had come into the opposite box with some friends, and she could not bear it. My mother took her back to her house in Gloucester Road, Regent's Park, telling me to sit quietly until she returned. When she did she said nothing to me, but I heard her tell Papa about it, and add: "I thought I should never be able to leave her; that man is a brute." Papa shrugged his shoulders and said nothing . . .'

The upshot was that Dickens never visited the Friths again. Mrs Frith made it plain where *she* thought the blame lay for the break-up of Dickens's marriage, However, 'Cissy' describes a visit she made with her father to Gads Hill on their own later.

Now for the somewhat involved story of that famous portrait of Charles Dickens in his study at Tavistock House, Bloomsbury, signed and dated 1859, which is to be seen at South Kensington, and which John Forster commissioned in 1845. It was not painted until five years later, because, about the time Forster commissioned it, Dickens began to grow a moustache. Forster thought this a 'fancy' of his friend's which would pass and so advised him to wait until he had got rid of the 'hideous disfigurement'. But, then, Dickens went on to grow a beard! Alarmed at the prospect of his sprouting whiskers next and so leaving Frith with little face to paint at all he revised his instructions and told Frith to get started.

As a result of the increasing use of photography, and the fact that Dickens was always so much a man in a hurry, and so increasingly reluctant to sit, the number of painted portraits of Dickens grew less towards the end of his life. Dickens was photographed by Mr Watkins in the black velvet coat we see him wearing in Frith's portrait. The artist found the photograph of little use to him, in the event. Dickens is seen in it seated in his study at Tavistock House, with the first pages of *A Tale of Two Cities* open on his desk.

'I never doubted your perfect success from the first moment I saw the canvas,'

[144]

Forster told the artist. 'The picture is, indeed, all I wished – more than I dared to hope – because I know what a ticklish thing a likeness is, and how portraits, otherwise admirable, fail often in that without which all other merits must fall short.' Dickens was less fulsome: 'It has received every conceivable pains at Frith's hands, and ought on his account to be good. It is a little too much (to my thinking) as if my next door neighbour were my deadly foe, uninsured, and I had just received tidings of his house being afire; otherwise very good.'

Agreed, great novelist though he be, his interest in art was of a somewhat casual order (except where the illustrations of his own books were concerned), but the following reflections of Dickens on the professional artists' models he found loitering about the steps of the Trinita del Monti in a letter to the Baroness Burdett-Coutts from Rome, dated 18 March 1845, provide us with a tailpiece to this chapter of great interest: 'I could not conceive how their faces were familiar to me, how they seemed to have bored me for many years.' Then Dickens remembered that he had seen them year in, year out, at the Royal Academy. There they all were: 'The Venerable Patriarch model, the Pastoral, the Assassin, and the Haughty Models, the women and children Family models . . . It is a good illustration of student life as it is that young men should go on copying these people elaborately time after time, and find nothing fresh or suggestive in the actual world about them.' (*Letters of Charles Dickens*, Vol. IV. 1844–1846, edited by Kathleen Tillotson, 1978.)

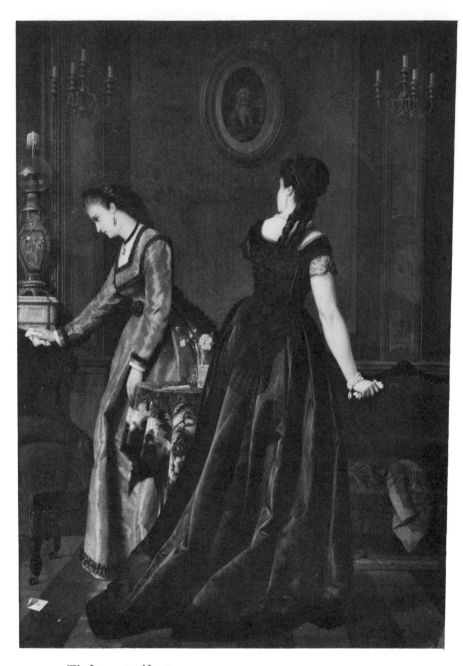

The Interrupted Letter.

1901. On a panel. 34¼ x 24¼ ins. Courtesy of Sotheby-Belgravia, London.

CHAPTER THIRTEEN

The Long Road Home

MANY BESIDES FRITH HIMSELF REGRET he never completed his *Streets of London* series since it was so clearly his forte, but there is no doubt that the agonizing delays and frustrations which bedevilled the production of *The Wedding of the Prince of Wales* (1865) seriously unsettled him. Many others besides his daughter, 'Cissy' must have been puzzled since as to how on earth he reconciled himself to turning out those countless copies, variations, and smaller scale samplings of his old work: 'The V – r of W – d' jobs; the Uncle Tobys and Widow Wadmans; the ceaseless illustrations of Sterne, Scott, and Sir Roger de Coverley: remembrances all of those days marked by a dog-eyed, youthful devotion to Dan Maclise: 'when Dan painted a man in armour, I painted one too'.

We have discussed this problem with dealers, museum authorities, members of Frith's family, and collectors, and at the end of the day my own tentative conclusions, for what they are worth are as follows: the market on which Gambart and Flatow went to town was firmly based on a rising market and the ready sale of engravings. But nothing lasts for ever. The rapid changes in photogravure and reproduction, in particular, hit Frith's income severely. He had had a good run for his money, and the brutal fact of the matter is that he outlived his vogue and public taste changed suddenly in a number of directions.

When painting *Derby Day* Frith's orderly programme was disrupted by the Drury Lane acrobat's fainting fits, and his son's happy notions that his studio was some kind of gym for him to throw himself around in, crashing into canvases, scattering lay models, and any other studio impedimenta that got in the way of his cartwheel practice, so Frith bought their clothes, slapped some money into their hands, and bid them 'Good day'. Professional models, 'to the manner born' took over, wore the clothes and gave satisfaction. No fainting fits; no cartwheels· The desire to be in complete control of his own artistic life was obviously important to Frith, and after his experience of boorish and inconsiderate sitters during work on *The Marriage*, he retreated into turning out copies of his own copies

for which he felt there was a predictable demand. He had had enough of complications and difficult sitters.

Moreover, too much has been made of his alleged smugness; his simple, unaffected delight in the number of times his paintings at the Academy required rails round them to protect them from the crush of visitors; his account of the money he made. His friend Anthony Trollope's sales slumped after he had published his *Autobiography* in which he listed, in neat, book-keeper style, what each of his novels brought him in. It was supposed to be bad form to talk about money; and if a man was ambitious, then, he was clearly a shade vulgar. That is all very fine if one is the son of a Duke or the chairman of an oil company, but since most of us *have* to worry about money (tiresome as it may be) and try and make something of our lives, even if only for the benefit of one's family, this is the silliest of affectations. Anyhow, he could hardly be expected to be over-impressed by the 'good form' of many of the high-born sitters he had to cope with whilst at work on *The Marriage*, albeit it heightened his appreciation of Jane Austen's mordant portrait of such social ornaments as Lady Catherine de Bourgh: a true photographic plate, etched in acid before the day of the camera had even arrived.

The impression we have of him is of a sensitive, alert observer of life, with a dedication to his craft equalled only by his genuine love of literature. We see him in our mind's eye, as 'Cissy' so vividly recalls him as she read to him the latest novel by George Eliot or his friend, Dickens, for hours at a time: 'The model on the "throne" yawns portentously; the light changes, she is dismissed, but we remain while the palette is cleaned and the brushes given their first bath of turpentine; then we are told to "cut off" and take the brushes to Wall to wash, while my father hums to himself, looks at the picture this way and that, lights a monstrous cigar and gets ready for the unfailing walk that takes him away from us – alas! – from the time his day's work is done until he returns to dress for dinner.'

Frith suffered from no illusions of grandeur: 'I know very well that I never was, nor under any circumstances could have become, a great artist', he writes modestly, yet few painters can have given so much delight to so many people with so few as three pictures: *Derby Day, Ramsgate Sands*, and *The Railway Station*. Yet the carping persisted even in the commemorative catalogue to the Festival of Britian exhibition of Frith's work staged in 1951. 'In the three volumes of his memoirs he writes of his art with the impenetrable satisfaction of a self-made business man, but with little of the enthusiasm of an aesthetic pioneer', complains Jonathan Mayne.

But, surely a man who had known the Royal Academy in the last stages of its Somerset House days, and conversed with Constable, Turner, Etty, Chantrey, and Eastlake (and shown a picture or so), could be allowed an opinion of his own?

In his *Magazine of Art* article, 'Crazes in Art, Pre-Raphaelitism and Impressionism', (1858), Vol. xi, pp. 187–191, the sixty-nine year-old Frith makes more telling points than those who have never bothered to look it up suspect. A modest man himself he felt that the old masters had something to tell him; unlike the Pre-Raphaelites: 'who proceeded to prove the justice of their nomenclature by refusing the guidance of any painter who had the misfortune in their wise young eyes, of being born after or contemporary with, Raphael'.

It is a matter of history that that movement fell apart before Frith braced himself for the effort of responding to the challenge of Impressionism. He writes: 'All art is impressionist in the true and wide sense of the term.' Vandyke had given us his impressions of Charles I and Strafford, but Vandyke was able to achieve precisely the effects he did because he was prepared to spend a great deal of time *perfecting his impressions*.

Not without cause, Frith felt himself qualified to advise the young student of 1888, beguiled by the challenge of the Impressionists, that their business after serving a long apprenticeship in drawing: 'is to learn to paint, by which I mean to acquire the power of thoroughly and completely representing – as the great masters did – the object before him, whether it be a human figure or any model. Let him throw nocturnes and symphonies to the winds . . . there is no royal road, but only the path I . . . have pointed out.'

To many of the young men coming up, doubtless Frith was regarded simply as a genial, cigar-smoking relic of the past, and few heeded him as he insisted that a thorough training in, and knowledge of, drawing was an absolute necessity for all who desired to arrive at excellence in art. He stressed that Reynolds himself had constantly expressed regret that he had not been more intensively trained in this area; this regret 'must be evident to all who are acquainted with the writings of that great genius'.

He then invited his readers to compare a Reynolds's portrait with one by Vandyke or Titian: 'In those of the last-named painters the features, with every detail, *are almost photographically rendered* whilst the breadth of effect is fully preserved. In Reynolds we have breadth of effect, or, in other words a generally truthful resemblance to Nature, with subtle detail omitted.' (Our italics: maybe it was precisely this *photographic* quality the Impressionists and their admirers most objected to!) It was the old, old story of the clash of generations.

Frith's suggestion that the student throw nocturnes and symphonies to the winds reminds us, of course, that Frith had appeared in the celebrated Whistler v. Ruskin trial of November 1878. Everybody had a day out and a lot of fun out of that trial, except poor Whistler (his own worst enemy) and the most sensible words ever uttered on that trial were those of Bernard Shaw, who said that Whistler should have forgotten about his artistic reputation and sued on com-

PRIVATE VIEW OF THE OLD MASTERS EXHIBITION, 1888, ROYAL ACADEMY OF ARTS, BURLINGTON HOUSE.

Painted in 1889 by H. JAMYN BROOKS.

Deposited on loan July, 1909, and presented by the Artist, April, 1919. (1833)

The following persons are represented in the order they appear, beginning on the left of the picture above:

1. Sir Watkin Williams-Wynn, Bart.
2. Henrietta Blanche, Countess of Airlie.
3. Charles Drury Edward Fortnum (1820-1899).
4. Sir Frederick William Burton (1816-1900).
5. Alfred Morrison (1821-1897).
6. The Lady Dorothy Nevill (1826-1913).
7. Sir John Everett Millais, Bart., R.A., afterwards P.R.A. (1829-1896).
8. Philip Burne Jones (now Sir Philip).
9. The Lady Marjorie Manners (now Marchioness of Anglesey).
10. Sir John Pender, G.C.M.G. (1815-1896).
11. The Marchioness of Granby (now Duchess of Rutland).
12. Baron Ferdinand de Rothschild (1839-1898).

13. Humphry Ward.
14. George Richmond, R.A. (1809-1896).
15. Edward Philip Monckton (1840-1912).
16. William Powell Frith, R.A., (1819-1909).
17. L. Alma Tadema, R.A. afterwards Sir Lawrence. O.M. (1836-1912).
18. John Evan Hodgson, R.A. (1831-1895).
19. Frank Holl, R.A. (1845-1888).
20. Susan, Countess of Wharncliffe.
21. Charles Butler (1822-1910).
22. James, Third Earl of Normanton (1818-1896).
23. The Lord Hillingdon (1830-1898).
24. The Earl of Wharncliffe (1827-1899).
25. Edward John Poynter, R.A., afterwards Sir Edward and P.R.A. (1836-1919).

26. Mrs. Alma-Tadema, afterwards Lady Alma-Tadema (d. 1909).
27. The Lord Wantage, K.C.B., V.C. (1832-1901).
28. Sir Richard Wallace, Bart. (1818-1890).
29. Henry Doyle (1827-1892).
30. Sir John Charles Robinson, C.B. (1824-1913).
31. Margaret, Countess of Jersey.
32. Philip Hermogenes Calderon, R.A. (1833-1898).
33. Miss Millais.
34. William Quiller Orchardson, R.A., afterwards Sir William (1835-1910).
35. Sir Frederic Leighton, Bart., P.R.A., afterwards Lord Leighton (1830-1896).
36. Alfred de Rothschild (1842-1918).

37. Mervyn, Seventh Viscount Powerscourt, K.P., P.C. (1836-1904).
38. The Lady Wantage (1837-1920).
39. John, Sixth Earl of Darnley (1827-1896).
40. George Scharf, afterwards Sir George and K.C.B. (1820-1895).
41. Edgar Boehm, R.A., afterwards Sir Edgar (1834-1890).
42. Victor, Seventh Earl of Jersey, P.C., G.C.B. (1845-1915).
43. Holman Hunt, O.M. (1827-1910).
44. Mrs. Street.
45. Henry Tanworth Wells, R.A. (1828-1903).
46. John Ruskin (1819-1900).
47. John, Fifth Earl Spencer, K.G., P.C. (1835-1910).

48. Sir Charles Tennant, Bart. (1823-1906).
49. Charlotte, Countess Spencer (1835-1903).
50. Miss M. Tennant (now Mrs. H. H. Asquith).
51. The Right Hon. William Ewart Gladstone (1809-1898).
52. The Lord Burton, K.C.V.O. (1837-1909).
53. Marcus Stone, R.A. (1840-1921).
54. William Agnew, afterwards Sir William (1825-1910).
55. John Callcott Horsley, R.A. (1817-1903).
56. George Frederick Watts, O.M., R.A. (1817-1904).
57. Ayscough Fawkes (1831-1899).
58. Fred Eaton, afterwards Sir Frederick (1836-1913).

Private View at the Royal Academy.

1889. Courtesy of the National Portrait Gallery, London.

A painting of the private view of the **Old Masters Exhibition** (1888) at Burlington House by H. Jamyn Brooks. Frith is standing sixteenth from left.

mercial grounds i.e. on the loss of income sustained by him as a result of Ruskin's attack: 'That sort of thing can be understood by lawyers, and he would have been awarded £1000. But in talking about his Artistic Conscience he could only raise a farthing – that being all conscience is worth in the eyes of the Law.'

As William Gaunt comments in *The Aesthetic Adventure* (Pelican Books, 1957): 'That Frith should have been chosen to stand on Ruskin's behalf is not one of the least curious features of the case. *Derby Day*, for instance, in subject and treatment was quite outside the range of Ruskin's sympathies . . . It is possible, however, that Ruskin wanted someone who could not be supposed to be biased in his favour.' Quite so. Frith gave evidence very much against his will: 'it is a very painful thing to be called on to give evidence against a brother-artist. I am here on subpoena. I had been previously asked to give evidence but declined.' Naturally, given his devotion to 'features, with every detail . . . *almost photographically rendered*', Frith did not think Whistler's *The Falling Rocket* worth the 200 guineas asked for it, and said that the picture of Old Battersea Bridge failed to convey the impression of moonlight to him, and that a painting lacking composition and detail could not be considered a work of art.

The story of the trial has been told often and we do not propose to tell it again here, but for the record, here are one or two exchanges in court between Frith and Whistler's counsel, Sergeant Parry:

PARRY Do you know one of Turner's works at Marlborough House called *The Snowstorm*?

FRITH Yes, I do.

PARRY Are you aware that it has been described by a critic as a mass of soapsuds and whitewash?

FRITH I am not.

PARRY Would you call it a mass of soapsuds and whitewash?

FRITH I think it very likely I should (*Laughter*). When I say Turner should be the idol of everybody, I refer to his earlier works, and not to his later ones, which are as insane as the people who admire them. (*Laughter*).

Baron Huddleston, the judge, intervened at this stage to observe that somebody described one of Turner's pictures as 'lobster and salad', (*Laughter*).

FRITH I have myself heard Turner speak of his own pictures as salad and mustard (*Laughter*).

PARRY Without the lobster. (*Laughter*).

The result of the Ruskin trial was unsatisfactory to both sides; Whistler

barnacled with impossible costs, albeit he chose to regard his award of a farthing damages as a triumph and wore the farthing on his watch-chain; and Ruskin so downcast that he resigned his Slade Professorship at Oxford on the grounds that he had 'no power of expressing judgment without being taxed for it by British Law'. The fact that his intemperate criticism of Whistler in *Fors Clavigera* for 'flinging a pot of paint in the public's face' had virtually taken away a man's livelihood never occurred to Ruskin.

Frith visited Italy in 1875 and made a second tour of Belgium and Holland in 1880. In 1890 he joined the ranks of the retired Academicians although he continued to send in a single, vestigial offering, as it were, up to 1902. He was created a member of the Royal Belgian Academy and of those of Antwerp, Stockholm and Vienna. Frith became a Chevalier of the Legion and personally received the badge of a C.V.O. from the hands of Edward VII at Buckingham Palace on 9 January 1908: his eighty-ninth birthday.

Although Frith became a legendary figure well before his death and was felt to be well past his best by most critics, he still persisted until pretty near the end in turning out those replicas of his earlier triumphs which so baffled 'Cissy'. She quietly notes that when Stephens took to praising her father's pictures in *The Athenaeum* 'Papa's pictures had ceased to sell – a fact which always struck me as very curious.' Towards the close of his life he could often be found at the Paddington Bowling Green. Change in fashion and the upkeep of two large families meant that this once-prosperous artist, who gleefully recorded the number of times rails had to be placed round his paintings to protect them, left only £1,310.

Frith died at his residence in St John's Wood on 2 November 1909, and after his cremation at Golders Green, he was buried at Kensal Green, just a few weeks short of his ninety-first birthday.

Controversy will continue to rage over the merits of William Powell Frith, as it did in his own lifetime, for many years to come yet, but few painters we feel have given so much pleasure to so many with so few pictures: *Ramsgate Sands* (1854); *Derby Day* (1858), and *The Railway Station* (1862).

It is with his *Derby Day*, which can be seen and studied at leisure any day at the Tate Gallery in mind, that I recall that moving passage in Henry Blyth's *The Pocket Venus* (1966), in which he describes how he journeyed along the Harrow Road to Kensal Green Cemetery and was escorted along the neatly-kept paths and past the forest of marble monuments that were the symbols of Victorian prosperity, until he was led aside into a little clearing near some trees, where the attendant indicated a spot which he felt must be the place he was looking for; 'but the head-stones were worn and indecipherable, and the stones at the foot had become dis-coloured and overgrown, so that it was not possible to discern what was written on them. Having indicated the probable grave, the attendant asked to be excused

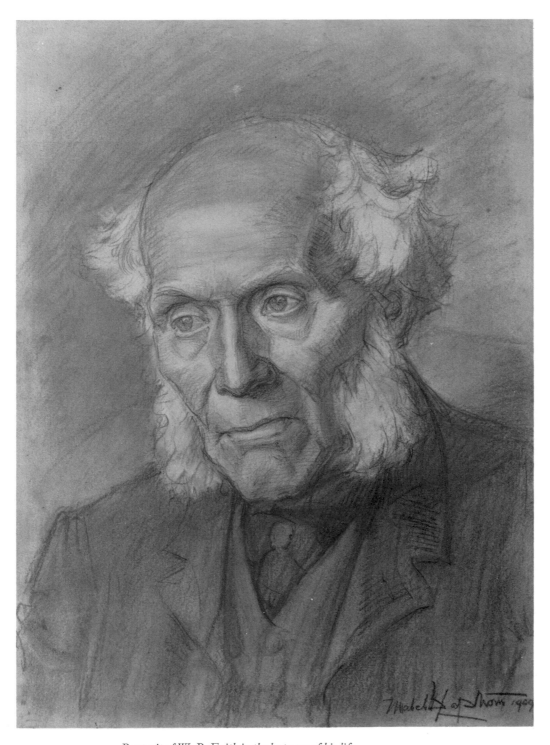

Portrait of W. P. Frith in the last year of his life.

1909. Courtesy of the National Portrait Gallery, London.

The artist is M. D. Lapthorn.

and withdrew. I was left to my thoughts and my investigations. The matted grasses could easily be removed, but the grime of a century lay on each worn stone. I took a handful of foliage and started to rub away the dirt on the stone at my feet until a few words became readable:

Sacred
To the beloved memory
of
Henry Weysford Charles
Plantagenet Rawdon Hastings

'It was June, and the air was warm and still. In the distance the tube trains could be heard as they rumbled their way towards Wembley and Harrow. No other sound came to disturb the silence, for the graves which surrounded me were all the same Victorian era, and there were no mourners present to look upon them or to lay on them the small bunches of flowers which were scattered over those in other parts of the vast cemetery.'

An odd spot for the Marquis of Hastings, maybe, whom Henry Blyth detects twice in Frith's *Derby Day*: as the Etonian in the shiny topper, cleaned out by the thimble-rig men; and as the drawling dandy in casual conversation with the gipsy girl, but somehow an appropriate setting for the obsequies of the great Victorian, who outlived his sovereign and so many of his contemporaries, and is now joined to them at Kensal Green. John Leech, Thackeray - so many of them are here.

Bibliography

ON THE SOUND PRINCIPLE that a man should be able to speak for himself ('he shall his own biographer be') Frith's *My Autobiography and Reminiscences,* 3 vols. 1887–88, form our basic source, usefully augmented by his daughter 'Cissy', Mrs. James Panton's *Leaves From a Life,* 1909, and *More Leaves From a Life,* 1911. Neville Wallis's abridged edition of Frith's reminiscences, *A Victorian Canvas,* 1957, incorporates the fruits of later research and help from Frith's descendants, notably the late Sir Godfrey Thomas, Bart., G.C.V.O.,K. C.B., his great-grandson, and Miss Flora Hastings, his granddaughter, who also, with other members of the family helped to make the Festival of Britain exhibition of W. P. Frith's work at Harrogate and Whitechapel, 1951, such a success. The catalogue of that exhibition is quite invaluable.

Since Frith was born in the last year of the reign of George III and survived to within two years of the accession of George V and Queen Mary, and began exhibiting at the Royal Academy in 1840, and despite his official retirement as an Academician in 1891, continued to show one vestigial work each year until 1902, his name crops up, naturally, in almost every standard work on nineteenth-century painting. Many of these simply regurgitate 'received opinion' on him as an artist and can be ignored without any great loss. The list below is simply a selection from the many works consulted which we have found helpful in varying ways.

Fortunately, the family have preserved many personal letters, sketches, and works by him, and we are much indebted to Diana, Lady Thomas, for the opportunity to examine them. There is also an important holding of Frith's letters (over 200) or letters received by him and his wife in the manuscript archives held by the Victoria and Albert Museum. Some of this has been utilized by writers at various times, as for example, by Kathleen Tillotson in her recently published volume of the *Letters of Charles Dickens,* Vol. IV, 1844–46, (O.U.P. 1978). His son, Walter Frith, who became a novelist published an entertaining interview-

article, 'A Talk with My Father', in the *Cornhill Magazine,* no. 119, May 1906 issue. Thus, one way and another, Frith is a fairly well-documented artist.

ALLDERIDGE, P. *The Late Richard Dadd (1817–86)*. Tate Gallery, 1974.

AMES, W. *Prince Albert and Victorian Taste*. 1967.

BECK, H. *Victorian Engravings*. Victoria and Albert Museum, 1973.

BLYTH, H. *The Pocket Venus: A Victorian Scandal*. 1966.

DAVIS, F. *Victorian Patrons of the Arts*. 1963.

ENGEN, R. K. *Victorian Engravings,* ed. H. Beck, 1975.

FORBES, C. *The Royal Academy (1837–1901) Revisited: Victorian Paintings from the Forbes Magazine Collection*. Introduced and edited by Allen Staley. Princeton, 1973.

FORSTER, J. *Life of Charles Dickens*. Annotated by J. W. T. Ley. 1928.

FREDEMAN, W. E. *PreRaphaelitism: A Bibliocritical Study*. 1965.

GAUNT, W. *The Aesthetic Adventure*. Pelican Books, 1957.

HALL, S. C. *Retrospect of a Long Life: from 1815 to 1883*. 1883.

HARDIE, M. *Watercolour Painting in Britain. Vol. III, The Victorian Period*. 1968.

HOLE, S. R. (Dean). *The Memories of Dean Hole*. Nelson, n.d.

HUTCHISON, S. C. *The History of the Royal Academy (1768–1968)*. 1968.

JEROME, J. K. *My Life and Times*. 1927.

LESLIE, C. R. *Autobiographical Recollections,* 2 vols. 1860.

LISTER, R. *Victorian Narrative Painters*. 1966.

MCMULLEN, R. *Victorian Outsider: The Life of J. A. M. Whistler*. 1973.

MASS, J. *Victorian Painters*. 1969.

Gambart: Prince of the Victorian Art World. 1976.

'The Prince of Wales's Wedding' (1865): The Story of a Picture. 1977.

MASSINGHAM, B. *Turn on the Fountains: The Life of Dean Hole*. 1974.

MILLAIS, J. G. *The Life and Letters of Sir J. E. Millais, Bart. P.R.A.* 2 vols. 1899.

ORMOND, L. *George du Maurier*. 1969.

ORMOND, R. *Daniel Maclise (1806–70)*. Exhibition Catalogue, National Portrait Gallery, 1972.

ORMOND, R. and L. *Lord Leighton*. 1975.

PERUGINI, M. E. *Victorian Days and Ways*. 1936.

REYNOLDS, A. M. *The Life and Work of Frank Holl*. 1912.

REYNOLDS, G. *Painters of the Victorian Scene*. 1953.

Victorian Paintings. 1966.

Charles Dickens Centenary Exhibition Catalogue. Victoria and Albert Museum, 1970.

SALA, G. A. *Twice Round the Clock; or the Hours of Day and Night in London*. 1859.

SCOTT, W. B. *Autobiographical Notes of the Life of William Bell Scott*. 1892.

STALEY, A. *PreRaphaelite Landscape*. 1973.
STEPHENS, F. G. *Memorials of William Mulready*. 1867.
TIDY, G. *A Little About Leech*. 1931.
TILLOTSON, K. (ed.) *The Letters of Charles Dickens. Vol. IV, 1844–46.* O.U.P. 1978.
WARD, E. M. *Mrs. Ward's Reminiscences,* ed. E. O'Donnell. 1911.
WOOD, C. 'The Dickens Sale: 9 July 1870' (essay in *Christie's Review of the Year, 1969–70,* ed. J. Herbert. 1970.
 Victorian Panorama: *Paintings of Victorian Life*. 1976.
 A Dictionary of Victorian Painters. 1971.

When Count de Suzannet was elected Vice-President of the Dickens Fellowship, he marked the occasion by presenting Dickens House, Doughty Street, with a reduced replica by Frith of his famous 'Forster' portrait of the novelist at South Kensington. For many years it had been in the possession of Mr. M. H. Spielmann, the historian of *Punch*. Frith himself survived Dickens by nearly forty years, and as Vice-President of the Dickens Fellowship himself, must have constituted for many members an important living link with their hero. Naturally, much information about such artistic gifts to Dickens House finds its way into *The Dickensian* and the researcher's task is much eased these days by the following publication: *A Cumulative Analytical Index to The Dickensian, 1905–1974.* Compiled by F. T. Dunn; foreword by M. Slater, Hon. Editor of *The Dickensian,* together with an Index to the illustrations compiled by M. Ford and M. Slater. The Harvester Press, 1976. It helps track down items like 'A New Portrait of Dickens: photograph used by W. P. Frith, R.A., for his painting of the novelist', by B. W. Matz (January 1919 issue, pages 37–39). There was a three-page tribute to him in the December 1909 issue at the time of the artist's death.

For invaluable contemporary opinions of Frith's work see especially such periodicals as *The Athenaeum, Art Journal, Punch,* and the *Illustrated London News,* as well as *The Times, The Morning Post* and the *Daily Telegraph.* The excellent exhibition catalogues issued these days are always a good source of fresh information (e.g. the recent Arts Council exhibition at Burlington House of Great Victorian Paintings, in which *The Railway Station* was on view). During the Dadd exhibition at the Tate, for example, not only was there on loan a self-portrait of Frith from the National Portrait Gallery (given to them by Frith's daughters), but the lesser known but attractive portrait of him as a young man, by his friend Augustus Egg, lent by the Harrogate District Council. It also came to light whilst mounting that exhibition that a portrait of Richard Dadd, wearing a fez, can be detected in the left-hand side of *Derby Day* in the Tate Gallery.

A NOTE ON THE TYPEFACE

This book was composed on the Monotype in Garamond, Series 156, a face cut in 1922 by the Monotype Corporation and based upon punches from the Imprimerie Royale, which had acquired an ascription to Claude Garamond. Four years later when it was too late to rename the series, the researches of Beatrice Warde identified the designer as Jean Jannon, printer to the Calvanist Academy at Sedan. Owing to political disturbances in 1615, Jannon was deprived of his type supplies from Frankfurt and in the space of six years he cut and struck a magnificent range of sizes. Based on Garamond's models, his design is much lighter and more open and characterized by the sharply-cupped top serifs. The italic is taken from a fount of Robert Granjon in the repertory of the Imprimerie Royale and was probably cut about the middle of the sixteenth century. A further series of italic was cut by the Corporation some years later, Series 174, which displays none of the eccentricities of letterform of the initial issue.